SECRET
KNARESBOROUGH

Paul Chrystal

AMBERLEY

Front cover: A classic view of the town taken from St John's church tower, and taking in many of Knaresborough's key features.

Back cover: Looking in the opposite direction, and at night.

First published 2014

Amberley Publishing
The Hill, Stroud,
Gloucestershire, GL5 4EP

www.amberley-books.com

Copyright © Paul Chrystal

The right of Paul Chrystal to be identified as the
Author of this work has been asserted in accordance
with the Copyrights, Designs and Patents Act 1988.

ISBN 978 1 4456 4340 3(print)
ISBN 978 1 4456 4348 9(ebook)

British Library Cataloguing in Publication Data.
A catalogue record for this book is available from the
British Library.

Typesetting by Amberley Publishing.
Printed in Great Britain

Contents

About the Author

Paul Chrystal was educated at the Universities of Hull and Southampton, where he took degrees in Classics. He has worked in medical publishing for thirty-five years, but now combines this with writing features for national newspapers, as well as advising visitor attractions such as the National Trust's 'Goddards', the home of Noel Terry, and York's Chocolate Story. He appears regularly on BBC local radio and on the BBC World Service. He is the author of over forty books on a wide range of subjects, including histories of Knaresborough and other northern places, the Rowntree family, the social history of chocolate, a history of confectionery in Yorkshire and various aspects of classical literature and history. He is married with three children Aand lives in York.

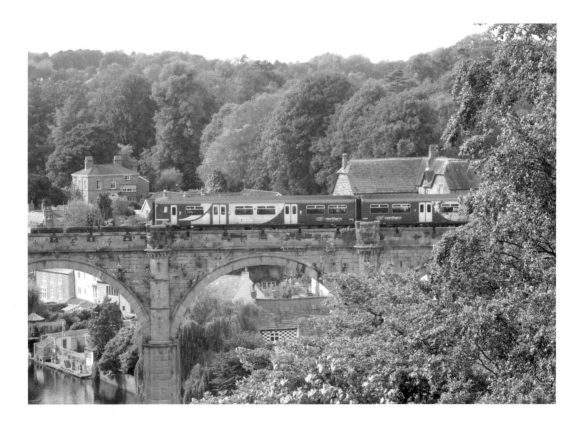

Knaresborough viaduct today.

Introduction

There can, of course, be few secrets left about a town so rich in history as Knaresborough. Historians from Hargrove to Grainge, from Jennings to Arnold Kellett have ably ploughed this furrow, turning up much historical information that is now very familiar to many who live here, and to others who have visited or studied the town. *Secret Knaresborough* is more about lesser-known facts – stuff that is less frequently documented or less well remembered. The book is full of arcane – some may say trivial – facts and, as such, provides a fascinating, intriguing complement to the existing histories of the town. As far as possible and practical, the book takes the form of a journey through Knaresborough, including the school, the castle, the marketplace, the high street and the river with its tourism and industry. There are chapters on Knaresborough's frequent brushes with royalty, and the numerous colourful personalities, who have been connected with the town down the years, follow. Finally, a miscellaneous chapter on events in the town's history, which defy categorisation, closes the book.

Paul Chrystal, York,
August 2014

One of the striking wall paintings that adorn Knaresborough during the annual *feva* festival.

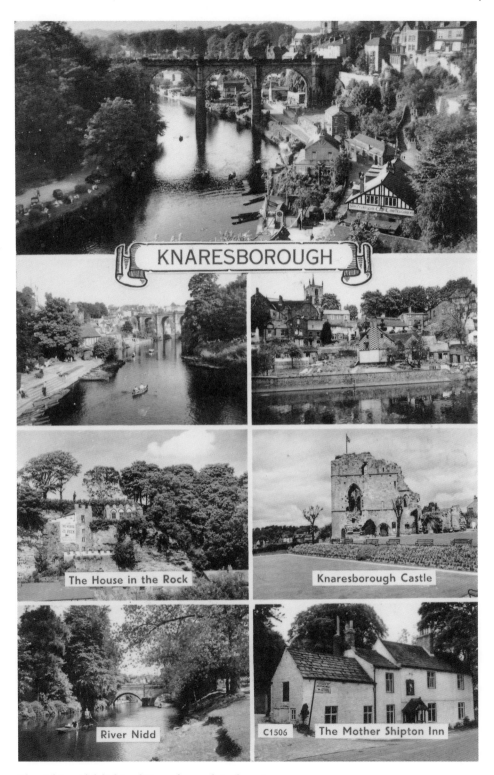

The sights and delights of Knaresborough in the 1960s.

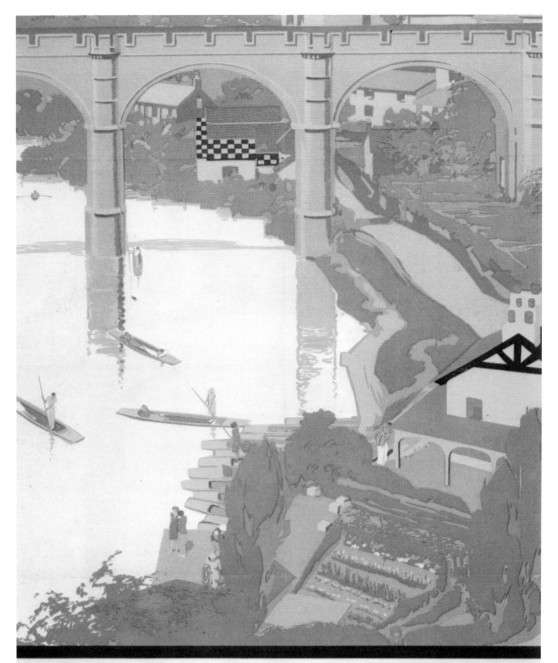

One of the many striking railway posters promoting Knaresborough.

Knaresborough in History

ANCIENT BRITONS

The ancient Britons are the earliest known inhabitants of the area around Knaresborough. The Celtic Brigantes tribe were the local inhabitants and were based around Iseur, to the north-east at Aldborough, near modern day Boroughbridge. The appointment of Quintus Petillius Cerialis, as governor of Britain, saw the beginning of the end for the Brigantes, their conquest continued by Gnaeus Julius Agricola, governor 78–84 AD. After 74 AD, the city (*civitas*) of Isurium Brigantum, Aldborough, was built over 60 acres, one of the most northerly of Romano-British towns. To find out more about Roman rule around Knaresborough, read Tacitus' *Agricola*.

ROMANS

The existence of Isurium Brigantum at nearby Aldborough, and the garrison at York (Eboracum), suggests Roman activity around Knaresborough. Roman coins have been excavated, the most famous find being in a second-century AD vase in Tentergate Drive. The Knaresborough hoard, a large find of bronze vessels and smith's tools, is in the Yorkshire Museum in York – (not to be confused with the twelfth century silver hoard, or the Viking hoard unearthed in Goldsborough in 1859 during the construction of Goldsborough church). Coins and artefacts dating from 700 to 1050 were discovered in a leaden chest, including fragments of Viking brooches and arm rings, together with thirty-nine coins, and is one of the largest collections ever discovered in the UK. It is

BOROUGH ARMS.

The borough arms, as featured in *A Popular Illustrated Handbook to Knaresborough Second edition* (1890).

now in the British Museum. During the second-century AD, the town took up 55 acres and was surrounded by a sandstone wall 8–9 feet thick.

THE PLOMPTON HOARD

The Plompton Hoard is a collection of over 600 coins found near Knaresborough in the 1990s. They were scattered in two main groups: the first, over 280 coins, found in 1990 the second, a further 270 coins excavated over the following three years. Another fifty coins were found in 2013; the hoard is now in the Yorkshire Museum. The coins are all from the Central and Gallic Empires, issued between 253 AD and 282 AD.

ANGLES

When the Romans left the area in the fifth century, the Germans came. The Angles gave their name to England, which was originally 'Engla-land', the land of the Angles. 'Knaresborough' may be derived from the name of an unknown Anglian chieftain (possibly Cenheard's burg), but is more likely to come from 'Knarresburg', meaning fortress on the rock. The common suffix '-burg' means fortified settlement, later becoming 'borough'.

THE SYNOD OF THE RIVER NIDD

The Venerable Bede talks of a synod held near the Nidd in 706 (Knaresborough?), in the reign of King Osred. In the first year of Osred's reign, Bertwald, Archbishop of Canterbury and primate of nearly the whole of Britain, came up from the south to judge Wilfred. The result was the reinstating of Wilfred, Bishop of Northumbria and Hexham, as requested by Pope John VI.

VIKINGS

The Norsemen tended to settle in the Dales, while the Danish Vikings, after taking York in 867, populated the Vale of York and the area around Knaresborough. This is reflected in street names such as Kirkgate and Briggate, and in traditions such as the Knaresborough sword dance and the odd custom of Hoketide, when men took off women's shoes on Easter Sunday to have their hats taken off by women the day after. It was the Danes who divided Yorkshire into the three Ridings (thirds) for military and political purposes.

NORMANS

Before the conquest, the majority of the land in and around Knaresborough was controlled by five landowners: Edward the Confessor, Gospatric (a leading Northumbrian chief), Gamelbar, Merlesuan and Archill. After 1066, the victorious Norman barons were allocated various manors, in gratitude for their support of William I. Serlo de Burgh built Knaresborough Castle, in Knaresborough manor, to serve as a base during the Norman scorched earth strategy. This was merciless in putting down any opposition, in what is euphemistically called the Harrying of the North in 1070 – not a single village was left standing between York and Durham. In 1141, the Normans also built the parish church (now St John the Baptist), owned by Henry I, youngest son of William the Conqueror.

DOMESDAY AND THE HARRYING OF THE NORTH

After the invasion, there were sweeping changes in local land ownership, with William's supporters and allies being amply rewarded. William himself became Lord of Aldborough and Knaresborough, and Merlesuan lost his lands to Ralph Paganel, Gamelbar to Gislebert Tison and William de Percy. Gospatric had ill-advisedly joined the rebellion against William, but later recanted and lost only some of his lands, including Copgrove and Little Braham, to Ernegis de Burun. He was allowed to keep Farnham, Staveley and Clareton. Archill kept all of his lands. William's objective was to consolidate the estates around Knaresborough and establish, or extend, the royal hunting forests to the west and south-west of the town. The national audit, initiated by William the Conqueror in 1086 (Domesday) shows that Knaresborough – spelt Cenaresburgh – was, like a lot of places hereabouts, in a parlous state following the Harrying of the North. Knaresborough and its berewicks, or affiliated villages, are described as having 'land for 24 ploughs. King Edward had this manor. Now it is the King's land, and is waste. In King Edward's time the value was six pounds. It now pays twenty shillings.' Simeon of Durham (died after 1129, and an English chronicler and a monk of Durham priory) gives a graphic account of William's scorched earth campaign:

> [William] devastated it throughout the winter and slaughtered the people ... it was horrible to observe in houses, streets and roads human corpses rotting ... for no one survived to cover them with earth, all having perished by the sword and starvation, or left the land of their fathers because of hunger ... Between York and Durham no village was inhabited.

Orderic Vitalis (born 1075) in his *Ecclesiastical History* adds that William

> wasted their lands and burnt their dwellings, he ordered the corn and cattle, with the implements of husbandry and ... provisions to be ... set on fire ... and thus destroyed at once all that could serve for life in the whole country lying beyond the Humber.

Refugees fled as far as to the Vale of Evesham, according to the *Evesham Abbey Chronicle*. Florence of Worcester, a monk who died in 1118, said that, from the Humber to the Tees, William's armies torched villages and slaughtered the inhabitants, no doubt raping the women as they went. Food stocks and livestock were all destroyed, so that anyone unlucky enough to survive the initial massacre died of starvation over the winter. The land was salted, to destroy its fertility and productivity for decades to come. The survivors were reduced to cannibalism. Devastation described the fate of estate after estate: a total of 60 per cent of all holdings became wasteland. Domesday tells us that 66 per cent of all vills contained wasted manors. Even the more prosperous areas of the county had lost 60 per cent of its value, compared to 1066. There was only 25 per cent of the population and few plough teams remaining – a reduction of 80,000 oxen and 150,000 people.

ROYAL MAUNDY

The first known Royal Maundy took place in Knaresborough in 1210, during a visit by King John. Records, including *Rotulus Misae*, reveal that, on 5 April 1210, *Die Jovis Cene* (the Day of

the Lord's Supper), King John was staying at Knaresborough Castle and gave Maundy gifts of 13 pennies each to thirteen poor men of Knaresborough: the gifts were a robe, breeches, a girdle, a knife and shoes. The figure of thirteen is a reference to the number of diners at the Last Supper, not to the monarch's reign or age, as suggested by later tradition, although a red purse of money is still given in lieu of clothing. On Good Friday, King John provided a meal for 100 Knaresborough paupers (costing 9s 4½d) and 1,000 more across Yorkshire (£4 13s 9d), both meals including bread and fish. *Rotulus Misae* is King John's account of his expenses (one of the oldest documents of its kind in existence), which proved beyond all doubt that he distributed Maundy gifts in Knaresborough in 1210. The extensive research leading to this conclusion was carried out by Arnold Kellett, and is accepted by the Royal Almonry. Dr Kellett staged a reconstruction of the occasion on Maundy Thursday 1987, and during the Millennium Pageant of 2000. In April 2010, the 800th anniversary celebrations of the first Maundy given by King John were held at the castle.

KNARESBOROUGH CHARTERS

Knaresborough's first recorded charter was granted by Edward II in 1310; it stated that 'Knaresborough be a Free Burg and the men inhabiting the same be Free Burgesses. They shall have one Market and one Fair, with the assize of bread and ale' – that is, the townsfolk had the right to fix a statutory price for staple food and drink. To the Earl, Piers Gaveston, and his heirs, the charter granted hunting rights in Knaresborough Forest, as well as in the deer parks of La Haye (Haya Park), Bilton and Haverah, and the privilege of judging malefactors, with the threat of a gibbet and gallows. The inhabitants of Knaresborough were exempted from the payment of various tolls throughout the kingdom. Undoubtedly, the charter increased the status of the town quite substantially.

KNARESBOROUGH BATTLE CASUALTIES

Knaresborough men fought in a number of significant battles, including Bannockburn (1314), when lots of Knaresborough men fell, including William de Vaux, Constable of the Castle. In the Wars of the Roses, Knaresborough men, including Sir William de Plumpton, were among the estimated 20,000–38,000 killed at the Battle of Towton in 1461. Knaresborough men were among the dead in the siege of Knaresborough Castle (1644), and also in the 1914–18 and 1939–45 conflicts.

THE BLACK DEATH

Bubonic plague wiped out a third of the population of England, and struck this part of Yorkshire in 1349. The Black Death carried off about half the population of Knaresborough, including the vicar, Robert de Neville.

CATHOLICS

During the Rising of the North in 1569 (the failed attempt by Catholic nobles from the north of England to depose Elizabeth I, and replace her with Mary, Queen of Scots), Catholics broke into Knaresborough parish church, destroyed the Protestant prayer books, and, for the last time, heard Mass in Latin. Catholics persisted in the area, in spite of strong opposition, and were responsible for the conversion of Guy Fawkes to Roman Catholicism, in Scotton.

In 1791, Catholics were again allowed to worship in their own licensed chapels and in 1797, a priest from the Catholic mission in Follifoot moved to Knaresborough, converting an old mill in Union Street into a Roman Catholic chapel. This was Father Anselm Appleton, a Benedictine, who, in 1802, left Knaresborough to become the first Prior of Ampleforth abbey. St Mary's Catholic church opened in Bond End in 1831, large enough to seat a congregation of 400. Soon there were 100 children being taught on the premises and, by 1851, there was a total of 250 practising Catholics in Knaresborough. The Mission of St Mary's is one of the oldest in the West Riding, with records going back to 1755.

THE PILGRIMAGE OF GRACE
A popular uprising, in 1536, by northern Catholics against Henry VIII's treatment of monks and monasteries. The following year, Henry VIII, going back on his promises, ordered the execution of 200 Catholics who had taken part, including Lord Darcy, steward of the Honour of Knaresborough, and Sir Thomas Percy, Lord of Spofforth.

THE CIVIL WAR
During the election in 1640, Royalist soldiers from the castle were running riot with their wild behaviour. In 1642, Sir Henry Slingsby of Scriven Hall took the castle for the King, handing it over to Sir Richard Hutton, until Col. Edward Croft was appointed commander. In June 1644, Prince Rupert, nephew of Charles I, attempted to raise the siege of York. He stopped briefly at Knaresborough Castle, and then faced Cromwell at Marston Moor on 2 July 1644. Captured Cavalier troops were marched through Knaresborough on 17 July, vilified and abused by their captors.

CLUBMEN
Clubmen carried clubs and other rudimentary weapons; they were groups of vigilantes who took it upon themselves to protect their possessions, keeping order during the Civil War when the town was crawling with foraging Parliamentarians and trapped Royalists. The leader of the Knaresborough Clubmen was a prominent dyer called John Warner. Warner, a fervent Royalist, took refuge in the castle during the siege and was fined a massive £100 for his 'delinquency'; his son, Simon, killed a Parliamentary soldier during a skirmish.

CHOLERA
There were cholera epidemics in Knaresborough in 1832 (thirty-two deaths) and 1848–49 (thirty-eight deaths); the latter terrified the inhabitants of Harrogate, who read in the *Harrogate Advertiser*: 'It is within a few miles of us. At our own door, and the next hour may see us laid prostrate under its withering touch!' Raw sewage dumped in the Nidd, as well as open drains and dunghills, was blamed and, in 1850, a start was made on public sanitation by laying a main sewerage pipe down the High Street.

THE FIRST WORLD WAR
The first Knaresborough man to volunteer for the Army was John Taylor, at a recruitment drive in Marketplace. The first to be killed in action was Pte Walter Malthouse, on 9 May 1915, aged twenty-one. By 1918, 156 Knaresborough men had lost their lives in battle. A

casualty in Knaresborough itself was Lt D. G. Turnbull of the Royal Flying Corps. The civilian contribution included all manner of fundraising events for the war effort, such as a concert in 1915 by the band of the Royal Scots Grays, whose commanding officer was Col. William Fellowes Collins, DSO, himself from Knaresborough. His wife, Lady Evelyn Collins, was matron of Knaresborough Hospital (the former workhouse), which tended to convalescent wounded servicemen. Convalescent soldiers were also housed in Conyngham Hall.

The Castle

BARBICAN GATE

The twin towers, at the main entrance to Knaresborough Castle, originally featured a drawbridge and portcullis. The gate features on a seventeenth-century seal, which is now Knaresborough's emblem.

THOMAS BECKET

The *Chronicle of John de Brompton* tells us that the four knights who murdered the Archbishop Thomas Becket in Canterbury Cathedral, on 29 December 1170, fled north and took refuge in Knaresborough Castle. Their leader, Hugh de Morville, was constable of the castle. The *Chronicle* adds that the castle dogs, taking the moral high ground, declined to eat the scraps the four murderers threw from their table.

THE CASTLE

Knaresborough Castle originates from the fortified settlement or burg, which the Angles named Knarresburg. It is strategically placed on a cliff towering over the Nidd, some 120 feet below. The fort was developed as a castle by the Normans, under Serlo de Burgh, a comrade of William I at Hastings. In 1130, Henry I authorised Serlo's nephew, Eustace fitz John, to develop the castle further, making it into a base for hunting wild boar and deer. In 1205, King John instructed Brian de Lisle to extend and fortify the castle, making it one of the most important military and financial centres in the north, from which John could control troublesome barons. In 1204, he commissioned a dry moat, and the manufacture of quarrels, or crossbow bolts, in the castle forges. In 1210 alone, 109,000 of them were turned out.

In 1212, when John's barons had become particularly fractious, the castle was on high security alert– two senior offices in the garrison were Roger the Crossbowman and Nicholas the Crossbowman. Rations for 1213/14 included 11½ quarters of beans (23s) and 3,000 herrings (10s 6d).

Between 1307 and 1312, the castle was completely rebuilt for Piers Gaveston by Edward II, and became a luxurious residence as well as a fortification, with twelve towers and a great keep – the total cost was a massive £2,174. After defeat at Bannockburn, Edward II had to defend against rebellions in England: on 5 October 1317, a rebel knight, John de Lilleburn, took Knaresborough Castle and held it until 29 January 1318, when it was recaptured by the King. Later that year, it proved too strong for the Scots to take. From 1328, the castle became the occasional residence of Edward III and Queen Philippa, and also their sons, Prince Edward, the Black Prince, and John of Gaunt. In 1372, Edward granted the castle and honour of Knaresborough to John of Gaunt, Duke of Lancaster, since which time it has

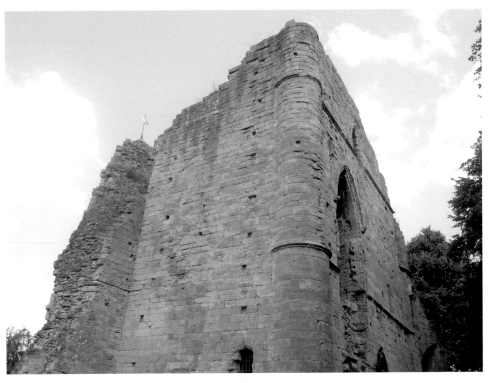

Above & Below: Two shots of the slighted castle today.

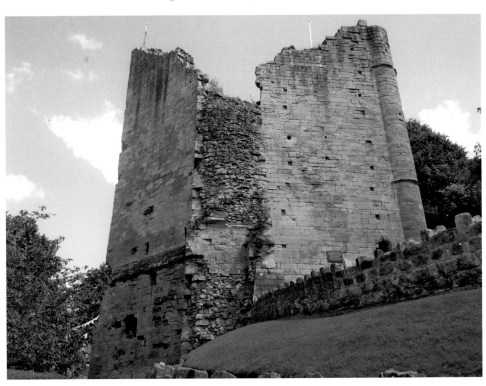

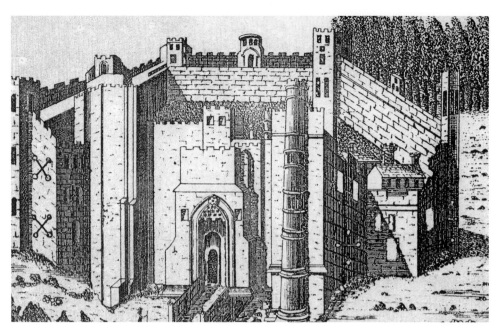

Knaresborough Castle as restored in 1590 by Queen Elizabeth I.

been part of the Duchy and so belongs to the Queen. In Tudor times, John Leland admired the castle:

> The Castel stondeth magnificently and strongly on a Rok, and has a very depe diche hewing out of the Rok where it is not defended by the Ryver Nidde, that there rennith in a deade stony bottom. I numbered a eleven or twelve towers in the waul of the castelle ... it is very hard to find a stronger syte or place more abill to be fortified to withstand the damage of gunnes or to be maid not prenabill

What we see today are the ruins of Edward II's castle, reduced to this state by Oliver Cromwell's slighting – the systematic dismantling of Royalist castles – carried out in 1648. Knaresborough Castle had been taken by the Parliamentarians in December 1644, after the siege. Little remains other than the barbican gate, the keep, and the dungeon. The ruins became a stone quarry for other buildings in the town.

THE SIEGE OF KNARESBOROUGH CASTLE

After Marston Moor in July 1644, Cromwell's forces advanced on Knaresborough, intent on taking the castle that had remained loyal to Charles. The first skirmish took place on 12 November, after which the Royalists retreated into the castle, with twenty men killed, forty-eight wounded and forty-six taken prisoner. The Parliamentarians lost twelve men and prisoners. The siege really got going at the beginning of December, when Col. John Lilburn, and around 600 Parliamentarian soldiers, attacked the castle. The Royalists made a spirited defence, sallying forth into the moat through the southern sally port and attacking

Saturday Magazine.

No. 100. JANUARY 25TH, 1834. { PRICE ONE PENNY.

UNDER THE DIRECTION OF THE COMMITTEE OF GENERAL LITERATURE AND EDUCATION, APPOINTED BY THE SOCIETY FOR PROMOTING CHRISTIAN KNOWLEDGE.

KNARESBOROUGH, YORKSHIRE.

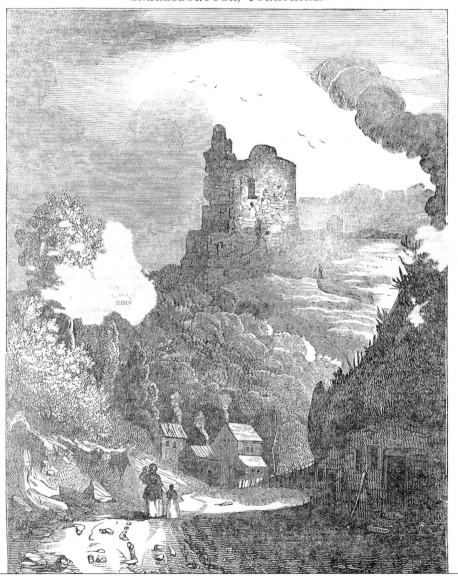

The castle, as depicted in an August 1834 edition of *The Saturday Magazine*, under the auspices of the Society for Promoting Christian Knowledge.

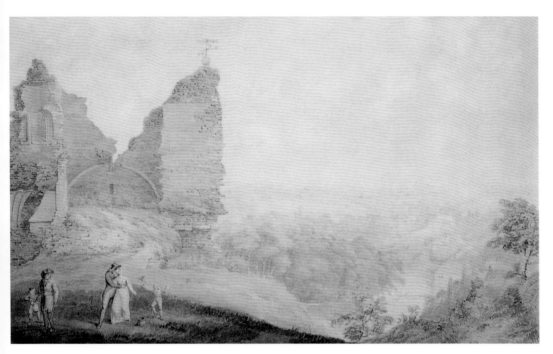

Thomas White's 1802 *Knaresborough Castle*, by kind permission of the Mercer Art Gallery, Harrogate Borough Council.

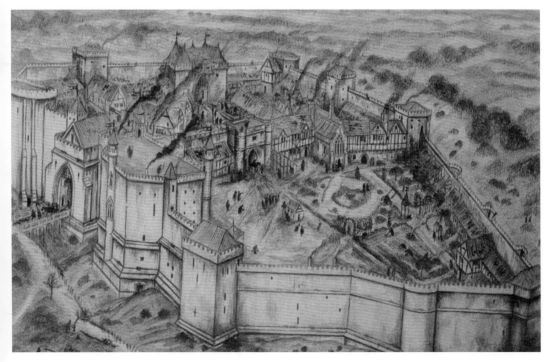

An artist's impression of the fourteenth-century castle, by Tim Frankland, painted in 1995.

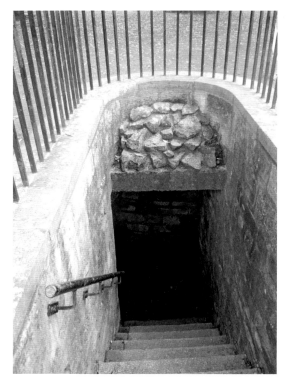

Left: The exit to one of the castle's sally ports.

Below: The war memorial today, in the castle grounds.

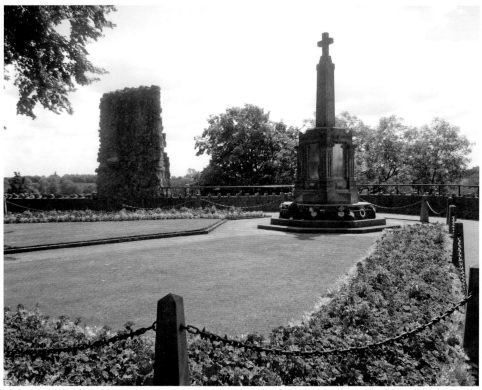

An unusual view of the castle from a card posted in 1909.

the besiegers, killing or wounding forty-two and taking twenty-six prisoners. But, on 20 December 1644, the Parliamentarians, firing their four cannon to the left of the barbican gate, breached the wall with an 11 foot by 6 foot hol, and the Royalist garrison surrendered, after being promised life and liberty.

THE DUNGEON

The best preserved part of Knaresborough Castle is little changed since its completion in 1312. Twelve arches radiate from a central pillar, the only dungeon in the country with this inverted mushroom-like structure. It was used as a storeroom and, of course, a prison, as evidenced by the medieval graffiti – the walls are 15 feet thick. Legend has it that prisoners, manacled to the wall, were moved around until they came into the shaft of light offered by the narrow window – they were then taken out and executed. No prisoner ever escaped from the dungeon.

THE CASTLE YARD TWELVE AND THE CASTLE YARD RIOTS

In 1865, there was a public protest in Knaresborough against Dr John Simpson, a JP and GP. Simpson lived next to Castle Girls' School, and had upset his neighbours when he fenced off a popular right of way, past the castle to the river. Led by William Johnson, a tailor, people had repeatedly tried to break open the locked gates, but Simpson resorted to violence when he struck Johnson with a stick. Eleven men, including Johnson (but not the JP Simpson), were arrested and imprisoned for three months. On their release, the Castle Yard Twelve were celebrated as martyrs, and each presented with an inscribed silver tankard by the grateful people of Knaresborough.

THE SEBASTOPOL GUN

This was originally displayed in a railed enclosure near to the War Memorial. It is a 24 -lb muzzle-loader cannon, captured at Sebastopol and presented to the town by Lord Panmure in 1857, soon after the end of the Crimean War. On special occasions, or for a small fee paid to Charles Coates, lumps of turf were fired across the gorge. Special occasions included the marriage of the Prince of Wales and the Queen's Jubilee celebrations. Ironically, the cannon and its railings were removed for salvage during the Second World War, to make more artillery and tanks.

SALLY PORTS

Tunnels were dug from within the castle, providing the garrison with a means of attack or escape during a siege. Two of these are the northern and southern sally ports, the latter open to the public since 1990. Other tunnels may have reached from the castle further into the town; one is known to have extended 140 feet from near Fysche Hall, in the direction of the castle. One source describes them as such 'certeyn privey stayres vawted, discending under the grownd, of clene hewen stone that goth unto the bothom of the ditches for making privey isshues and excursies'. One was about 90 feet long, with a portcullis halfway along. By the mid-sixteenth century, they were 'mured or dampyned' (walled up).

THE WAR MEMORIAL

The memorial, erected in 1921, originally boasted a more elegant top, but this was blown off in the 1930s; it was then replaced by a stouter cross, after a destructive gale in 1956. The famous inscription reads, 'Greater love hath no man than this, that a man lay down his life for his friends.' (John, 15:13)

THE COLLAPSING CASTLE

On 19 August 1905, some of the ruins on the east side of castle yard, near to the girls' school, fell down in three large pieces, each weighing 4 tonnes.

Marketplace

THE MARKET

The first reference to a market in Knaresborough is in 1206, but this market was surely predated by the early Norman market at a time, when the marketplace extended as far as the castle, whose garrison it would have supplied with food, drink and other provisions. By 1310, Edward II's Charter had established Wednesday as market day. In Tudor times, Leland noted that 'the market there is quick', that is, busy and active. The market was famous for its locally grown liquorice and cherries, but corn was the chief product: Knaresborough market sold more corn each week than any other market in Yorkshire, according to Hargrove (1809).

In 1896, the Knaresborough Urban District Council approved tolls of 1d for every basket of produce brought in weighing between 14 and 28 lb, 1d for every basket or crate of fowls, 3d for every two-wheeled cart and 4d for every four-wheeled wagon load. In the early twentieth century, the market was famous for its street theatre and its characters. For example, there were the Morrisons, who juggled with dishes, plates and chamber pots, allowing them to slip and smash from time to time to pull in the crowds; there was Jim Plummer the fishmonger; Frank Smith the 'Corn King'; and a dentist who extracted teeth in public, as shown in the painting by J. B. Fountain.

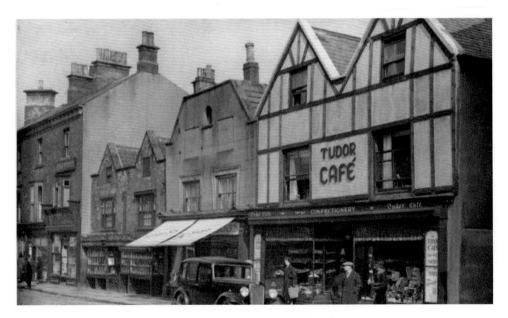

A fascinating colour photograph of the Tudor Cafe in the marketplace.

Above: The marketplace, resplendent with bunting from the 2014 Tour de France, which passed through the town. Blind Jack looks on, as it were. The bronze statue is the creation of Barbara Asquith.

Below: Wirelesses were all the rage at Parrs in 1926.

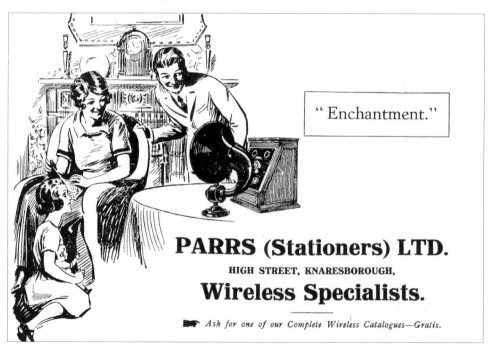

Just some of the things you could buy at the Oldest Chemists Shop in England in 1890.

THE MARKET CROSS

The market cross has something of a chequered history. The circular stone base dates from 1709, added when a new cross was erected. This was replaced in 1824, when a gas engineer, John Malam, donated a gas lamp. The arrival of electricity meant that this too was replaced by a hideous transformer and a tall stand, with lamps on three branches. In 1953, to celebrate the Queen's Coronation, a market cross was reinstated, although this was not without its detractors. A supposedly fourteenth-century style cross in a circle now adorns the marketplace.

THE OLD ROYAL OAK

This marketplace inn dates back to the eighteenth century, and is notable because it has its own priest hole.

THE OLDEST CHEMIST SHOP IN ENGLAND

An apothecary from about 1720, when John Beckwith was behind the counter. The inventory of an earlier apothecary, Ralph Metcalfe, shows that in 1689 he stocked no less than 280 different herbs, oils, unguents and chemical powders for his medicines and remedies. Until 2003, the shop retained many of the original features, including box-windows on legs of 'Chinese Chippendale' (added about 1760), an oak-beamed ceiling, old drawers and coloured bottles, a bleeding couch, a leech jar, a huge pestle and mortar (turned by a dog), a pill-making machine, and a small rack which once held quills of quicksilver, worn to repel diseases and witches. All were once used by the best-known chemists there, W. P. Lawrence and his son Edmund, who sold everything from corn cures to sheep dip. Sadly, the Oldest Chemist Shop in England closed in 1997. In the dungeon-like cellar was another treasure trove of the chemist's pharmacopeia and inventory, including mercurial ointments for use on sheep – this was produced by means of the turn spit – a barrel or cage in which dogs known as turnspit dogs worked the pestle, in much the same way as hamsters work their cages. After Metcalfe, the apothecaries were Coupland, Gervais, Pullan, Acomb, Potter and Lawrence.

PICKLES' OINTMENTS

A pharmaceutical company brought to Knaresborough in 1967 by Stanley Horner. In 1994, Pickles bought the Oldest Chemist Shop, which chimed nicely with its own successful products, such as 'Snowfire' and 'Fiery Jack'. Pickles' Ointments still trade today.

PARRS THE STATIONERS

Taking over from A. W. Lowe at the end of the nineteenth century, William Parr's, at the entrance to the marketplace, became Knaresborough's essential stationer, bookseller and printer, especially of Parrs *Knaresborough Almanack* and various brochures and booklets on the town. By the 1920s, Parrs was selling not only books and magazines, but running a small library and a showroom for toys, fancy goods, fountain pens, and the new novelty – the wireless.

STATUS HIRING FAIR

Status is a corruption of the term Statutes, originally referring to regulations for the engagement of labourers in the reign of Edward III. The 'Status' or 'Stattis' in Knaresborough was the hiring fare, when farmhands and servants were taken on for a year and a day. Traditionally held on the market day before or after 23 November, the women and girls went to the town hall, and the men and boys lined up in the High Street. Before the First World War, young boys were being offered up to £15 a year, girls and women £20, and men £30, with board and lodging extra.

High Street, Kirkgate and Beyond

BOXING

In the 1930s, usually on Monday evenings, popular bouts were held in the boxing ring behind the Elephant & Castle, High Street. The Knaresborough boxer, Leslie 'Dot' Fowler, was well-known throughout the northern England; he later ran a barber's shop at the bottom of the High Street.

CLARO

The wapentake (the name for the old subdivision of a shire), which included Knaresborough, as well as Harrogate, Boroughbridge and Ripon, extending as far as Middlesmoor to the north-west and Wetherby to the south. Wapentake is a Viking word, meaning a show of weapons for voting, while Claro is a Norman name associated with Claro Hill, about 4 miles to the north-east of Knaresborough. Claro is probably derived from Old French *clarion* – a trumpet or bugle, which was used to summon people together.

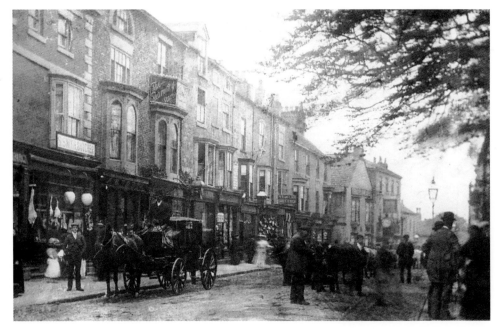

A busy High Street in the early twentieth century.

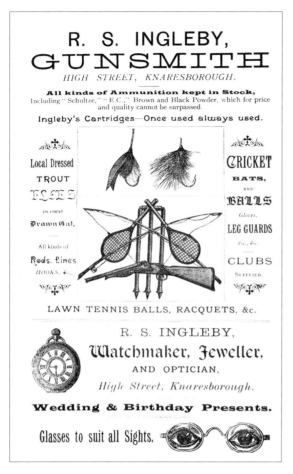

Gunsmiths in the High Street and horticultural builders in Iles Lane.

DOGS' GRAVEYARD

In the grounds of Conyngham Hall, this graveyard consists of around twenty-three dog graves, with diminutive headstones harking back to the days of the Woods, the Charlesworths (post 1905) and the Mackintoshes (post 1924). The inscriptions include: Tiger (1859), Cora (1862), Kelpie (1873), Sweep (1875), Jack (1877), Queenie – *Semper Fidelis* – (Ever Faithful, 1879), Rover (1919), and Dear Old Dandy – died 1932 aged fourteen.

GRACIOUS STREET

Because there have been (and still are) several places of worship on or near Gracious Street – United Reformed Church, Quaker, Methodist and Anglican – it is often assumed that the street was called 'gracious' because it is an apt name derived from the presence of these chapels and churches. The name, however, is derived from Anglo-Saxon *gracht hus* (literally ditch houses), and refers to houses built on the town's main ditch, or defensive moat, which became an open sewer. This ran along what is now Gracious Street, and which, in the nineteenth century, was called Grace Church Street.

Right: Knaresborough Spa in Starbeck.

Below: Harrrogate, the competition. This fine picture of Christ church on the Stray was first published in Grainge's 1871, *The History of Harrogate and the Forest of Knaresborough.* It is credited to Armitage & Ibbetson, Bradford.

Knaresbro' Spa Baths, Starbeck.

CAUTION!

NO PURE MILD

Sulphur Baths and Water

ARE TO BE OBTAINED BUT AT THE

ORIGINAL SPA BATHS,

THROUGH THE ARCHWAY.

25 PER CENT. REDUCTION IN PRICE.

Warm Bath - - - 1/6
Do. with Shower 2/-
Shower - - - - 1/-
15s. per Dozen.

JOHN HODGSON, PRINTER, HARROGATE.

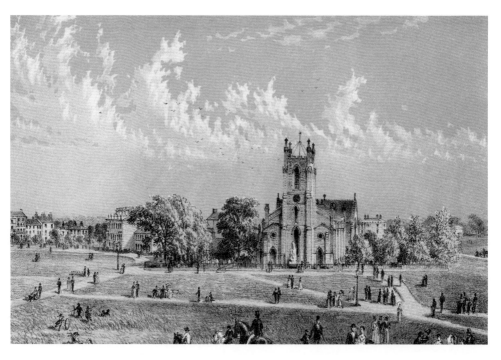

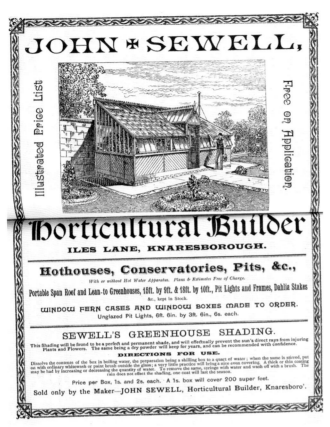

Left: Advert from a horticultural builder.

Below: The old tannery and Clapham's garage –now flats since 1984.

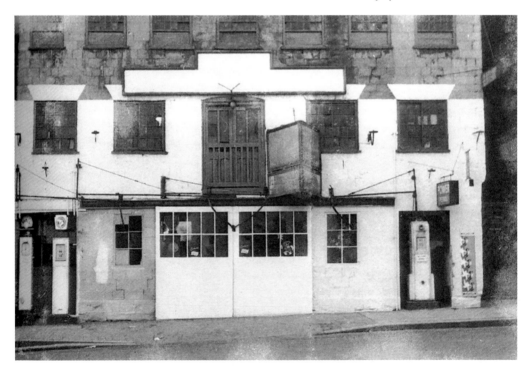

Tudor Cottage in Kirkgate.

KNARESBOROUGH SPA

More Starbeck than Knaresborough, it was built on land enclosed in the boundary of Knaresborough by the 1778 Enclosure Act. There had been an earlier spa, revived by Knaresborough chemist Michael Calvert and Dr Peter Murray. In March 1822, the public meeting held in Knaresborough town hall formed a trust with 100 shares. That May the foundation stone of a new pump room was laid by the masons of England, following a procession from the Elephant & Castle, High Street. By 1828, a suite of baths had been added for both warm and cold bathing. The (usual) claim was that, for those who regularly drank the waters – both sulphur and chalybeate –'the digestion becomes amended, the bowels and kidneys perform their functions in a more regular manner ... and the skin itself gradually assumes a natural and healthy state'.

In the seventeenth century, Knaresborough Spa, was *the* place for 'taking the waters', long before Harrogate had developed. Various publications evidence this, notably, Dr Deane's *Spadacrene Anglica* (1626), which recommends those staying in Knaresborough to visit not only Harrogate mineral springs such as the Tewit Well (the first to be discovered, in about 1571, by William Slingsby and named after a Spa in Belgium), and the Old Sulphur Well, but also those at Starbeck, the Dropping Well, St Robert's Well and St Mungo's Well at Copgrove. St Robert's irritated Deane, because of the gullibility of the 'great concourse

of people ... especially the female sexe, as ever more apt to be deluded'. Knaresborough Spa never managed to rival Low Harrogate, with their grand hotels and, by about 1890, it had closed. Some of the early buildings can still be seen near the Star Beck, on Spa Lane, including the later Prince of Wales Baths (1870). 'Knaresborough Spa' had also been used to describe Knaresborough itself in the seventeenth century.

An analysis of the waters by Professor John Attfield in May 1889 revealed them to include, among other dissolved substances, the following: 61.936 grains of chloride of sodium, 12.559 grains of carbonate of sodium, 11.240 grains of carbonate of calcium, 7.840 grains of carbonate of magnesium – total dissolved substances: 102.254. As with other mineral waters, small traces of lithium, barium and strontium were also found. Attwood concluded that this water was, 'mildly saline, antacid and sulphurous ... it is entirely a mineral water, being quite free from any objectionable animal or vegetable matter.'

THE OLD TANNERY
Dating from the eighteenth century, this building in York Place was first a tannery, symbolic of Knaresborough's traditional trade in leather and shoemaking. It then became a small linen mill, and then, in the 1950s, included Clapham's Garage. It was converted into flats in 1984.

ALMSHOUSES
A plaque at the top of Kirkgate marks the site of almshouses 'for six poor folk', as mentioned in a document from 1611. Others, near High Bridge, were demolished to make way for the Claro Laundry in 1902.

GALLON STEPS
The ninety-six steps leading from the end of Kirkgate to Waterside are nothing to do with water being carried up from the river, as popularly believed. They are named after Mr Richard Nicholas Gallon, born in 1789, who lived in the house at the top – Nidd Pavilion – and later moved to Hawkshead, Cumbria, where he died in 1834. The circular sally port is nearby.

JOCKEY LANE
This lane, connecting High Street with Kirkgate, gets its name from the horse dealer who once had his stables here. There was once a synagogue here too, which led it be called, at various times, Barefoot Lane or Ten Faith Lane.

WATER BAG BANK
At the lower end of Kirkgate, where it goes down to the Nidd, is the only fully cobbled street left in the town. Its name comes from the leather bags of water, which for centuries were carried up here from the river, usually slung across the backs of donkeys and horses. Women too carried pails of water up the hill, at a halfpenny a time. This was, however, never Knaresborough's only source of water.

Places of Worship and Schools

THE BELLS OF ST JOHN

In 1774, a peal of eight bells was installed in the parish church of St John by the vicar, the Revd Thomas Collins. The cost (£462 3s) was kept down by using four melted-down old bells, said to have come from Knaresborough priory. The bells were retuned in 1925.

The ringing of a bell from the church tower goes back to the Normans, when the curfew bell was rung. The pancake bell was rung on Shrove Tuesday, and a bell was rung to guide people to Knaresborough on the eve of market day, which is why bell-ringing practice is traditionally on Tuesday night. Another old tradition was to toll the bell to announce a death – thirty strokes for a man, twenty for a woman and ten for a child.

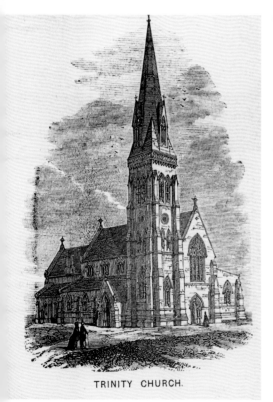

TRINITY CHURCH.

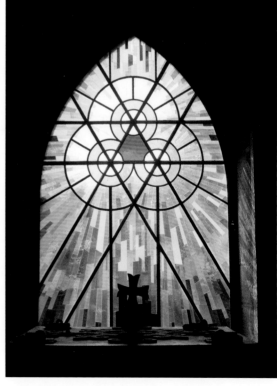

Above left: Holy Trinity church in Gracious Street, built in 1856; its lofty spire is 166 feet high. Published in *A Popular Illustrated Handbook to Knaresborough 2nd edition* (1890).

Above right: One of the beautiful windows in Holy Trinity church, which replaced a doorway.

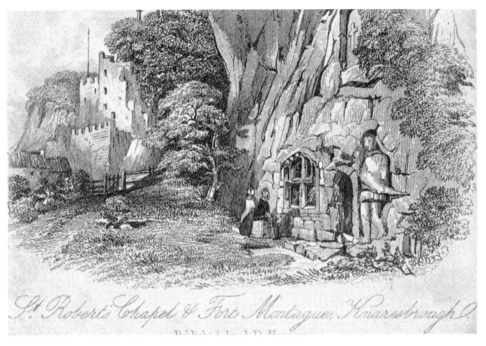

Chapel of our Lady of the Crag.

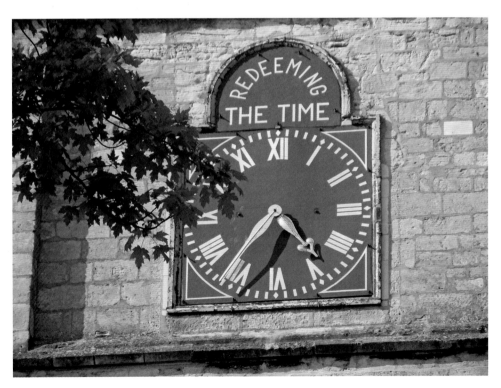

St John the Baptist – Knaresborough's parish church clock.

THE JEWISH SYNAGOGUE

This was once at the Kirkgate end of Jockey Lane, and the ginnel here from the marketplace is still known as Synagogue Yard. Hargrove records that a Jewish phylactery was found in the castle area, in 1738, and a remnant of the medieval wall of the synagogue was uncovered in 1768 by Christopher Walton. The phylactery featured an inscription in Hebrew, preserved in the manuscripts of Roger Gale Esq, and 'is a recital of part of the sixth chapter of Deuteronomy, from the beginning of the fourth verse, to the end of the ninth'. The Jews probably left Knaresborough in 1275, before being expelled with other Jews from England in 1290.

CHAPEL OF OUR LADY OF THE CRAG

This chapel is often wrongly called St Robert's chapel, due to confusion with St Robert's Cave, also in the rock face, but nearly a mile further down the river. The chapel was cut out of the crag, near Low Bridge, by John the Mason in 1408, and is reputedly the third oldest wayside shrine in Britain. At 10 feet 6 inches long, 9 feet wide and 7 feet 6 inches high, it was, according to an 1880s guide to Knaresborough, 'elegantly hollowed out of the solid rock, its roof and altar beautifully adorned with Gothic ornaments'. The entrance is guarded by the figure of a knight holding a sword. The knight is 'in the act of drawing his sword to defend the place from the violence of rude intruders'. Wordsworth visited in 1802, alluding to it in *Effusion*. Some, including Wordsworth, took this soldier to be one of the Knights Templar. Now officially recognised as a chapel by the Vatican, the 1890 edition of the guide describes the interior: 'Behind the altar is a large niche, where formerly stood an image; and on one side of it a place for the holy water basin. Here also are the figures of three heads designed ... for an emblematical allusion to the order of monks (*Sanctae Trinitatis*) at the once neighbouring priory, by some of whom they were probably cut.' A later image of the Madonna and Child, dated from 1916, was added when the shrine was restored by John Martin. He gave it to Ampleforth abbey, on whose behalf it is now looked after by the parish of St Mary's, Knaresborough. The current statue was carved by Ian Judd and dedicated in 2000. The chapel is too small to accommodate a congregation, but Mass is occasionally said outside.

KNARESBOROUGH PRIORY

The priory of St Robert of Knaresborough, never officially an abbey, was founded a few years after the saint's death (1218) in 1252, by the Trinitarian friars. Their full name was The Order of the Holy Trinity and of the Redemption of Captives in the Holy Land. The order was founded in France by Felix of Valois and John of Matha in 1197, with the aim of collecting ransom money for Saracen prisoners. Following the example of St Robert, they travelled and collected alms, recognised by their white robes, which were marked by a distinctive cross of a red upright and a blue cross-bar. They divided the money into three parts: the first was for the upkeep of the priory, the second for the poor of Knaresborough and the third for paying the ransom of prisoners taken by the Saracens during the Crusades. Their rules forbade them to ride on horses, though donkeys were acceptable, or to enter taverns. More like the Augustinians at Bolton priory than fellow mendicants– the Franciscans and Dominicans – they

Eugene Aram's school in White Horse Yard (now Park Place), shown in 1745. Richard Houseman's heckling shop is to the right.

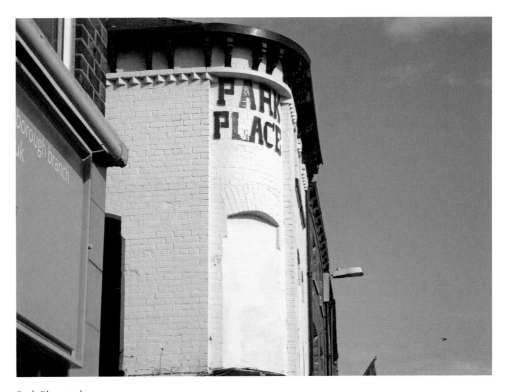

Park Place today.

The Old School House in the High Street.

were never very big, with sixty-eight friars between the ten English houses in the fourteenth century.

In 1257, their first known charter was granted by King John's youngest son, Richard, Earl of Cornwall and Lord of Knaresborough. The site of the priory was on the inaccurately named Abbey Road, just below the chapel of Our Lady of the Crag, on land roughly between the houses known as 'the Abbey' and 'the Priory'. The latter had fragments of the original priory built into its garden wall, and the gable end of an outbuilding. A coloured stained-glass window, showing the priory gatehouse, can be seen in Pannal church, founded in 1343 by John Brown, one of 'the brethren of the House of St Robert'. The original chapel, destroyed by Robert the Bruce, was restored by Edward III in 1318. Archbishop Thoresby, ordained in 1366, stated, 'that in future the cloister and dormitory should be kept free from the invasion of secular persons, and especially women of doubtful character, day and night'. One of the organisers of the Pilgrimage of Grace was friar here in 1533. In 1538, the priory was suppressed on the orders of Henry VIII. It was the only branch of the Trinitarians in Yorkshire. The Earl of Cornwall was very generous towards the monks of Fountains abbey, allowing them privileges in his forests, and free right of passage over the Ure, between Boroughbridge and York.

THE TOWN MISSION

At the top of Briggate, also known as the Primitive Methodist chapel, built in 1854. The main Methodist chapel was in Gracious Street from 1815; it was also called the Waterloo chapel, after the battle. It could hold 800 people. There was a third chapel in the High Street.

KING JAMES'S SCHOOL

The school was founded in 1616 as King James's Grammar School, by Goldsborough-born Revd Dr Robert Chaloner, Rector of Amersham and a Canon of Windsor. When asked, King James had granted permission for the school in record time, no doubt glad to have his name quickly established in an area associated with the man who had tried to kill him – Guy Fawkes. The school was for boys only, 'as well poor as rich', and still possesses the charter, headed by a portrait of King James, and the 'Ordinances and Lawes' – Chaloner's original school rules from 1616.

Discipline was strict, and the master was keen to see that his boys did not come to school 'uncombed, unwashed, ragged or slovenly'. He was to 'severely punish swearing, lying, picking (pockets), stealing, fighting, quarrelling, wanton speech, uncleane behaviour and such like'. Parents had to supply 'candles for the winter' (when school started at 7 a.m.) and a bow and arrows for the games period, as practice for the inevitability of war. There was great emphasis on grammar, both in Latin and English, on the Catechism, the Creed and the Psalms. In later years, the school motto was taken from Psalm 116: *Quid retribuam Domino?* 'What shall I give back to the Lord?'. Anyone 'unapte to learne' after a year was expelled. There was zero tolerance too on absenteeism: 'he shall be utterly expelled' – unless caused by illness. In the early days, school started at 6.00 a.m. in the summer, 7.00 a.m. in the winter, with an assembly in which the boys recited, on their knees, not just any old Psalm but the longest of them all: Psalm 119 (176 verses); the Creed, the Lord's Prayer and the Catechism. After their first year, they had to converse in Latin at all times, including playtime.

The first school was a house overlooking the parish church, given by Peter Benson and rebuilt in 1741. Under the hard, caning headmaster, H. J. Tyack Bake, King James's Grammar School moved, in 1901, to a site in York Road. Here it became, from 1922, one of the leading grammar schools in Yorkshire, under the outstanding headmaster, A. S. ('Sam') Robinson. Under Frank Brewin, the school celebrated its 350th anniversary with the registering of a coat of arms and, in 1971, it combined with the secondary schools of Knaresborough and Boroughbridge as an eleven–eighteen comprehensive. On 29 February 1972, it was officially opened by the Duchess of Kent. Today's uniform incorporates three Stuart tartans, a reminder of the failure of Guy Fawkes to murder King James I.

OTHER SCHOOLS

Knaresborough has had many private schools, including various 'dame schools', Eugene Aram's school, Thomas Cartwright's school in Gracious Street (where Bishop Stubbs was a pupil), the school in Castle Mill, Clarendon House Academy, Miss Carrie Pullman's school and, in the 1940s, Clevedon School. *Baines's 1822 Directory* tells us that there were ten other schools in Knaresborough at the time, including Thomas Cartwright's (classical and commercial), and the aptly named Sarah Fairlass School for Ladies, on the High Street.

The River Nidd

THE RIVER NIDD

Nidd is derived from a Celtic word meaning 'bright' or 'shining'. Eugene Aram's thesis (1759) was that it is from a word meaning 'below' or 'covered', because it disappears underground in Upper Nidderdale, and is a name related to words like 'nether', and to other rivers (e.g. Welsh Nedd and Neder), which are partly underground. The Nidd has always been essential to Knaresborough's economy. It was a means of transport, a source of fish, power for the water-wheels of various mills for corn-grinding, textile manufacture , as well as tourism in the form of boating. In 1818, it supplied the power for seven lead mills, one cotton mill, eighteen flax mills and twenty-two corn mills – forty-eight mills in total. The Nidd also supplemented the wells of the town by supplying drinking water, though sewage was, until Victorian times, dumped in the river. The Nidd has frozen over several times,

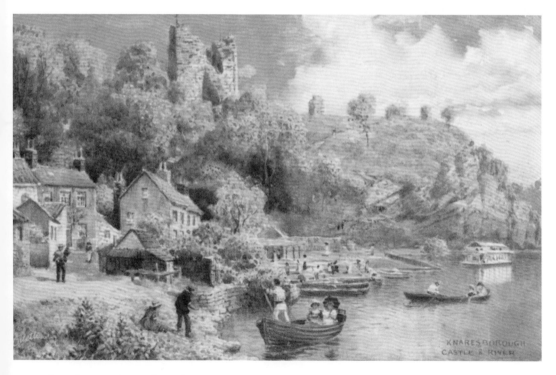

A busy boating day on the Nidd in the late nineteenth century.

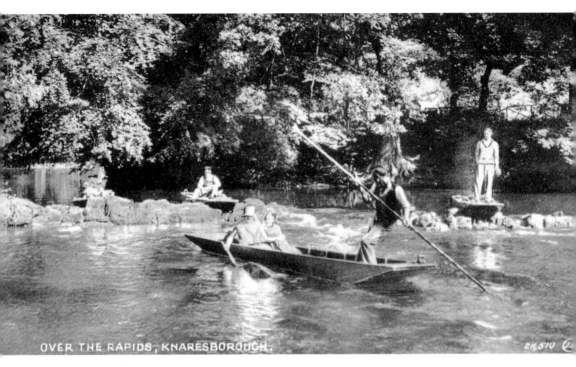

OVER THE RAPIDS, KNARESBOROUGH.

The Nidd further upstream.

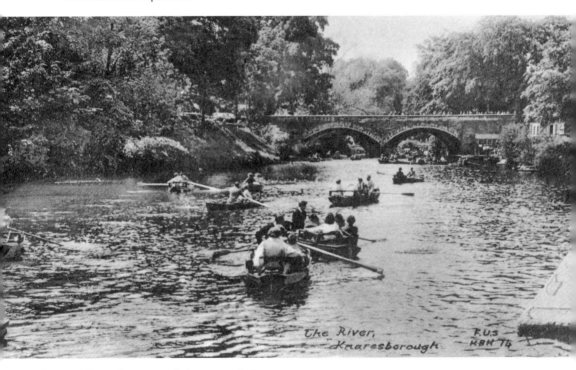

The River, Knaresborough

The rapids have always provided an extra challenge.

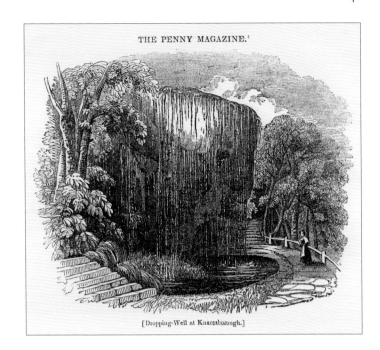

[Dropping-Well at Knaresborough.]

The Dropping Well, as depicted in *The Penny Magazine* of September 1837, published by the Society of Useful Knowledge.

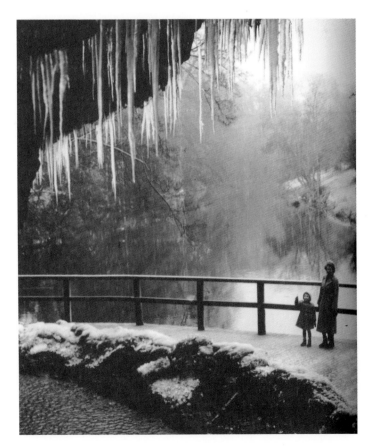

Lethal looking icicles festoon the Dropping Well on a freezing January 1959 winter day.

including 1916, 1929, 1940, 1943 and 1947, with photographic evidence depicting sliding and skating. Many have drowned in the Nidd, especially in the notorious stretch that is Cherry Tree Deep.

CHAFFEY DAM

Also known as Chappy Dam, and originally 'Chapman's Dam', referring to the mill it served. This is a weir on the Nidd, with an ancient right of way across the river marked by stepping stones. On 15 April 1917, a Royal Flying Corps pilot, Lt D. G. Turnbull, was tragically killed here.

THE DROPPING WELL

One of Britain's oldest tourist attractions, this petrifying well derives its name from the water that drops over a limestone rock into a small pool, before joining the Nidd. Our earliest known description is by John Leland, the antiquary of Henry VIII. After his visit in 1538, he wrote of 'a Welle of a wonderful nature, caullid Droping Welle. For out of the great rokkes by it distillith water continually into it ... what thing so ever ye caste in and is touched of this water, growth ynto stone.' A tourist attraction since 1630, the Dropping, or Petrifying, Well has intrigued visitors, with its 'alchemical' ability to change everyday

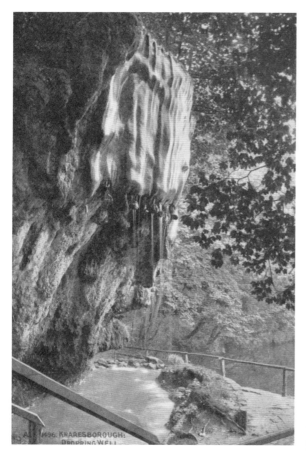

The Dropping Well with its petrified paraphernalia.

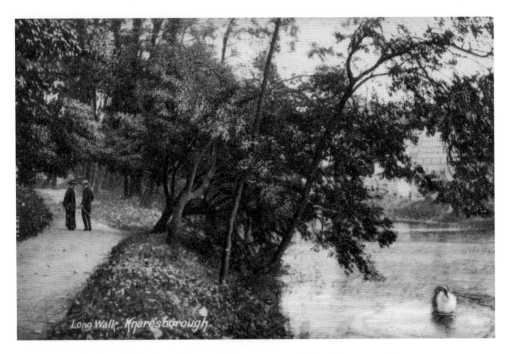

The Long Walk along the banks of the Nidd from a postcard dated August 1906.

objects into stone by depositing layers of calcite. 700 gallons of water flow through every hour; it takes approximately six months to 'petrify' a teddy bear, for example. Today, the well features a highly imaginative array of articles, some of which are in the local museum. Nowadays, the overhang is regularly scraped to prevent collapse, as happened in 1704, 1816 and 1823. Neither Leland nor any other early visitor refers to any nearby cave, later claimed to be the birthplace of the Tudor prophetess Mother Shipton, though the two are now inescapably associated. The writer of the article on the Dropping Well in the *Penny Magazine* of 9 September 1837 described the water as 'the sweetest water I ever tasted'.

The 12-acre Dropping Well estate, with the Long Walk, was owned by the Slingsby family until 1916, when it was sold off by auction. The Long Walk was used by Madame Doreen, palmist and clairvoyant, who gave special consultations by appointment. In 1986, it was bought by a company headed by Frank McBratney and Paul Daniels, and its name was changed to Mother Shipton's Cave Ltd. In 2001, it was taken over by Adrian and Elizabeth Sayers.

FOOLISH WOOD
The wood overlooking the Nidd, opposite Conyngham Hall, was part of the royal hunting ground. Its odd name is probably derived from 'foal-house close', suggesting this was where horses were bred.

THE HOUSE IN THE ROCK
Built into the crag overlooking Low Bridge, this unique dwelling was excavated and built by a poor weaver, Thomas Hill, and his son, between 1770 and 1791. They also terraced the

FORT MONTAGUE.

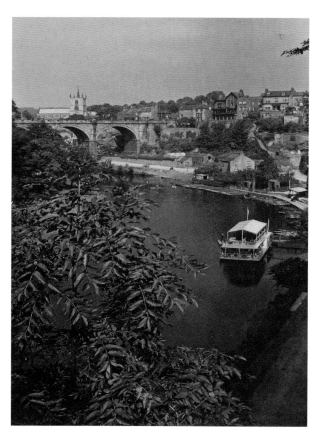

Above: A simple depiction of the House of the Rock, published in *A Popular Illustrated Handbook to Knaresborough 2nd edition* (1890).

Left: Another photograph of the 'surprise' view, showing *The Marigold* in the foreground, viaduct and St John the Baptist parish church.

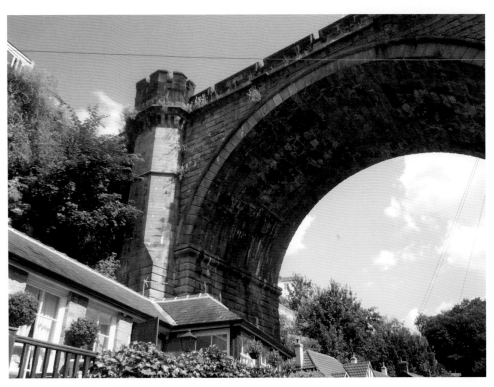

Above & below: Two shots of the railway viaduct in 2014, including a York to Harrogate train crossing the viaduct, August 2014.

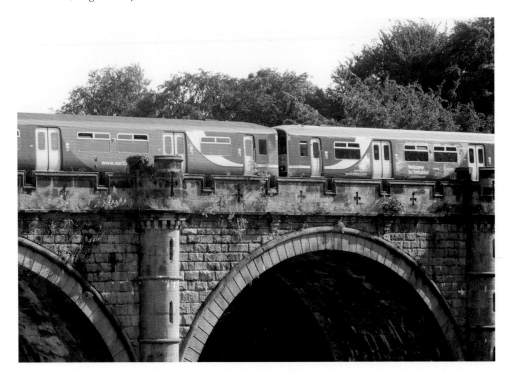

46

Above & Below: The viaduct, and a train crossing above the frozen River Nidd in 1947.

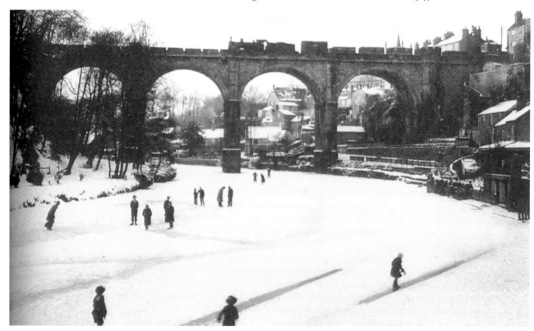

adjacent land and made a tea garden. The house was then finished off with battlements, and named Fort Montague in honour of the Duchess of Buccleugh, its principal benefactress. The son, who had sixteen children and was styling himself 'Sir Thomas Hill', flew a Union Jack from the battlements, fired salutes from a 2-pounder cannon and printed his own banknotes. 100,000 are estimated to have been in circulation by 1812, but only promising to pay '5 half-pence'. Sometimes also called 'The Swallow's Nest', the house became 'The House in the Rock' in the 1930s. For 200 years it had been a popular tourist spot, with visitors in more recent years shown around the house by Miss Hemshall and her niece, Nancy Buckle. In 1994, it was closed by Harrogate Borough Council, partly for safety reasons. Despite international media interest in the campaign, generated by Nancy Buckle and her supporters to keep it in the public domain, the house was put on the market by Ampleforth Abbey in 1997, and has been a private residence since 2000.

KNIGHTS TEMPLAR
This military religious order, formed for the protection of pilgrims to the Holy Land, had its principal northern training ground at Ribston Hall. The effigy guarding the chapel of Our Lady of the Crag is thought to be that of a Knight Templar.

THE MARIGOLD
The name of the houseboat, which in late Victorian and Edwardian times was moored between Sturdy's boat landing and Castle Mill. Owned for most of its life by the O'Reilly sisters, who also ran the Moat Café, it housed a stylish restaurant, serving food on the upper deck. Sometimes *The Marigold* sailed out on the river, especially during the Water Carnival. Due to gradual deterioration, it sank during the early 1920s. The riverside Marigold Café preserves the old name.

NANNY GOAT HOLE
A shelter on the way down the crag, where goats once grazed, below the castle. It was used to house a searchlight during the Water Carnival.

THE OLD MANOR HOUSE
A charming riverside house, taking its name from the old manor of Beechill, though it stands just outside this. According to W. A. Atkinson, it was not the actual Beechill Manor House that stood opposite the parish church. It is of great antiquity, being built around an ancient roof-tree, now concealed in a cupboard, with a chequered exterior. Two stories about the Old Manor House have no historical basis. First, it was supposed to be a hunting-lodge used by King John. Second, it is thought 'Cromwell slept here' and, according to the novelist Halliwell Sutcliffe, even signed a treaty here with Charles I. Atkinson rightly argued that the Cromwell story came from the bed in which he slept (at the house in High Street), which was moved here and placed in the beautifully panelled Cromwell Room. From the seventeenth century, the Old Manor House was owned by the Roundell family for nearly 400 years. It has been a riverside restaurant, but is now a residence.

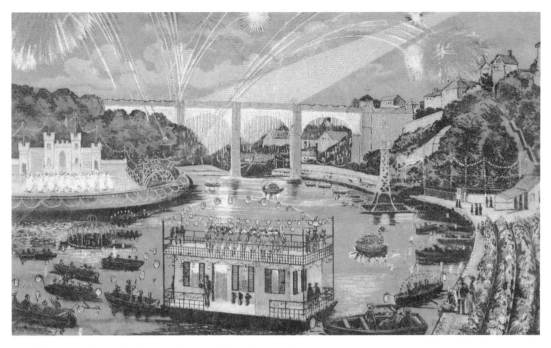

The splendid multicoloured, all action Water Carnival.

THE PENNY FERRY

To save visitors on Waterside a long walk round to get to the Dropping Well, young George W. Smith, a boatman with Sturdy's before the First World War, started his popular 'Penny Ferry', rowing a boatload of up to six visitors across the river at a penny each.

THE RAILWAY VIADUCT

One of the most dramatic incidents in the history of Knaresborough was the disastrous collapse of the first railway viaduct across the Nidd, at 12.15 p.m. on Saturday 11 March 1848. The apocalyptic crashing of falling masonry is said to have lasted a full five minutes. The foundation stone had been laid the previous April by Joseph Dent of Ribston Hall, High Sheriff of Yorkshire amid great rejoicing. But poor workmanship, shoddy materials and heavy rain led to it crashing into the river just before it was completed. Tom Collins, later MP for Knaresborough, narrowly missed being crushed. There was no loss of life, except for the multitudes of fish, killed by the lime in the mortar. Waterside was flooded to a depth of 12 feet, and much damage was done. Eventually the viaduct was rebuilt to a design by Thomas Grainger at the joint expense of two railway companies to a cost of £9,803. The contractors Duckett and Stead finally completed this spectacular structure, 90 feet high, 338 feet long, with four arches of 56-foot spans – and it was opened on 1 October 1851. Nicklaus Pevsner, with uncharacteristic myopia, deplored the way the railway cut through the heart of the town, but J. B. Priestley admired how the viaduct, reflected in the river, 'added a double beauty to the scene'.

THE WATER CARNIVAL

We do not know when the first Water Carnival was held, but it was at its heyday in the late Victorian and Edwardian midsummers, when great crowds filled the seats, specially constructed by Kitching's, below the castle. Some idea of the spectacular entertainment is given by extant colour postcards and programmes. There was the houseboat *Marigold* in midstream, with a band playing on its upper deck, a procession of flower bedecked boats led by the 'Fairy Queen of the Carnival'. There were mandolin bands, pierrots and glee choirs on floating platforms of punts or boats tied together, and the backcloth of a fairy palace and dancers on the far bank, in the Dropping Well estate. There was the spectacular, frightening tightrope stunts performed fearlessly by Don Pedro, pushing a man across the Nidd Gorge in a wheelbarrow, the Water Carnival at night, with illuminated boats, a myriad of coloured fairy-lights set up by George Smith, and firework displays by Brocks, with fire raining down from the viaduct to simulate Niagara Falls. There was a Water Carnival in 1913, with huge crowds and receipts of £560. With the First World War the tradition lapsed, until it was revived after the Second World War, and held throughout the 1950s. The crowning of a carnival queen survived in the later Children's Day.

The Textile Industry

Dating from the thirteenth century, the manufacture of linen was a thriving cottage industry in Knaresborough, reflecting the spread of a rural cloth industry throughout Yorkshire to compete with the urban-centred industries at York and Beverley. Water-powered fulling mills were at the core of this development, built for the thickening and felting of cloth. Before the mills, cloth had been fulled by walking or trampling, on it; the mills were, therefore, called walking mills, while the fuller was termed a walker. The first fulling mill at Knaresborough was mentioned in 1284; it was on the north bank of the Nidd above the High Bridge. It crops up again in the sixteenth century, when it is described as being in 'walkmyln lonnying',(lane) on the Coghill (Conyngham) Hall estate. This places it near Tentergate, named after the frames on which the cloth was stretched to dry, post-fulling or dying.

Poll tax returns for 1379 reveal that a number of the skilful Flemish weavers, invited to England by Edward III, found their way to the Knaresborough area. Two John Brabanners, from Brabant, found work at Ripley and Spofforth, while others of the same name settled in Lower Nidderdale and Wetherby. Adam Brabaner lived in Knaresborough; Goldsborough, Nidd and Plompton also had their useful migrant workers. Richard de Cadby was a dyer living in Scriven with Tentergate. Fulling mills existed at Bishop Thornton, Nidd and on the south bank of the Nidd opposite Knaresborough.

Flax was at first grown locally, then imported from the Baltic via Hull – rising from 500 tonnes in 1717 to 2,300 tonnes in 1783. There are many references to people in Knaresborough carrying out retting, boiling, bleaching, heckling, dyeing, spinning and weaving. Writing in 1787, Hargrove says that 'Upwards of one thousand pieces of linen (20 yards by 35 inches) are manufactured in this town and neighbourhood each week.' By 1820, there were twenty-four small firms in the town manufacturing linen, as well as a dozen linen merchants and drapers. Later in the nineteenth century, the linen industry was concentrated in various mills, especially Walton's.

CASTLE MILL

Built in 1770 on the banks of the Nidd under the castle, this was originally a paper mill, which used the waterwheel that had pumped water up into the town since 1764. It was rebuilt as a cotton mill in 1791, adapted for the spinning of flax and weaving of linen in 1811. By 1847, it had been taken over by the biggest employers in Knaresborough, John Walton, established in 1785. Walton's produced top quality linen, as reflected in their appointment by Queen Victoria in 1838 as 'suppliers of all the royal palaces'. Castle Mill flourished under Walton, who increased their workforce to 423 by 1851, the year they won the Prince Albert Medal at the Great Exhibition.

Women and children made up the majority of the mill workers; here are the numbers for the 120 time workers at Castle Mill:

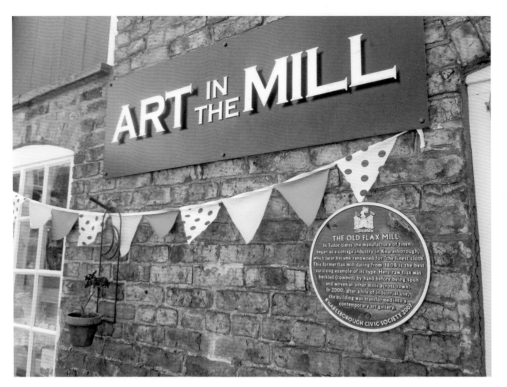

Art in the Mill – a wonderful gallery doing justice to the site of the old flax mill in Green Dragon Yard, Castlegate.

Age	Number of Males	Average Weekly Earnings	Number of Females	Average Weekly Earnings
10–12	4	2s	5	2s 3d
12–14	11	2s 6d	8	3s
14–16	8	3s	11	3s 6d
16–18	2	5s	8	5s
18–21	3	6s	10	6s
> 21	15	6s	35	6s

Corporal punishment was forbidden at Castle and Plompton Mills, but at Scotton, 'as little corporal punishment sanctioned as possible; sometimes a few stripes given with a light strap to children under 14 years old', and no more than once a day. William Forster complained of the lack of suitable workers, saying that he was forced to employ the 'dregs of society', and that his workers were 'refractory and very bad to govern'.

The depression of the 1830s and 1840s obviously had dire consequences for the industry. In 1839, a parliamentary commission sent a commissioner to Knaresborough in 1839 to examine the causes of hardship amongst handloom weavers. There were 404 looms in

the town, most of which belonged to the manufacturers. The weaver's net wage averaged
7s 4d a week, while that of a carpenter and mason, was 24s and 21s respectively. There
were sixty-eight out of work weavers depending wholly on poor relief, with a further thirty
weavers dependant on supplementary allowances. Some weavers had already left the town
for Barnsley, a producer of fine linens, leaving 130 cottages empty.

The last production of linen at Castle Mill was in 1972; the firm left Knaresborough
in 1984, when the building was sold by Harrogate Borough Council for residential
development, though some of the external features of the mill were retained.

THE DYE HOUSE

Dyeing was obviously an important aspect of Knaresborough's textile trade. The
best-known dyer was John Warner, whose former dye house can be seen to the right of the
bottom of Gallon Steps. The inventory, made at his death in 1657, included a wide range of
colourants, such as indigo, woad, logwood, madder and 'scuttin neeale' (cochineal), as well
as the all-important mordant, alum. The dye house also contained nearly 900 yards of cloth.
The business was carried on by Simon and Thomas Warner, then by William Ibbetson, but
eventually declined. In more recent years, the dye house was used by Sturdy's for storing
boats and, in the 1960s, it housed a small children's zoo.

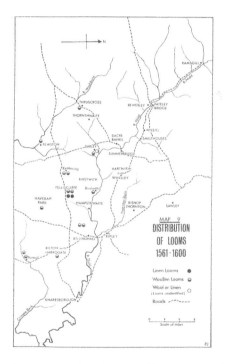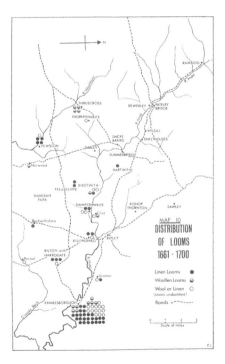

Two maps showing the distribution of looms in and around Knaresborough; the
proliferation in Knaresborough. The maps were originally published in *A History of
Harrogate and Knaresborough*, and reproduced with permission by the Harrogate WEA
LocaL History Group.

Knaresborough and Royalty

KING JOHN

History has not treated John well, but he was a considerable benefactor to Knaresborough. He developed and fortified the castle, appointing the very able administrator Brian de Lisle, and used it not only as a stronghold, but as a base for hunting deer in the Forest of Knaresborough. Sometimes accompanied by Queen Isabelle, he stayed here on seven occasions – in 1206, 1209, 1210, 1211, 1212, 1213 and 1216 – visiting Knaresborough far more than any other of the Yorkshire castles, with the exception of York and Pontefract.

The most crucial of these visits was 1210, when King John fed and clothed thirteen Knaresborough paupers during Holy Week – the first Royal Maundy. In 1216, a few months before he died, he made a pilgrimage to the hermitage of St Robert, granting him half a carucate (40 acres) of land, on which was later built St Robert's priory.

BRIAN DE LISLE

King John's right-hand man in Knaresborough, appointed as constable of the castle in 1205. He later became the King's Seneschal and, in the last year of his life (1233/34), was appointed High Sheriff of Yorkshire. De Lisle oversaw the development of the castle, the production and export of many thousands of crossbow bolts, the first known Royal Maundy and the King's visit to St Robert. His stipend was £48 13s 4d a year – enough to ensure his loyalty.

EDWARD II

Though his reign was largely a failure, Edward II also brought much benefit to Knaresborough. In 1310, he appointed his favourite, Piers Gaveston, to Lord of Knaresborough, and granted the town its first known charter. He also authorised the complete rebuilding of Knaresborough Castle on the site previously developed by King John. In January 1312, Edward had to take refuge in Knaresborough Castle due to the rebellion led by his cousin Thomas, Duke of Lancaster. Thomas refused to support the King when he marched north to raise the siege of Stirling, in 1314. From York, he issued orders to all men between sixteen and sixty to join his army. These included men from Knaresborough, among them William de Vaux, constable of the castle. He, and many townsmen, lost their lives in battle when Edward was defeated by Robert the Bruce at Bannockburn.

PIERS GAVESTON

Exiled by Edward I because of his corrupting influence on his son, this French-speaking Gascon was recalled to England after the King's death. Edward II not only broke his promise to his father, but also promoted his favourite to Earl of Cornwall and Lord of

Edward VII, at No. 45 Kirkgate.

Knaresborough. To please Gaveston, he then authorised the complete rebuilding of Knaresborough Castle, turning it into a palatial residence. In 1310, he also granted the town a charter, in which Gaveston's privileges and hunting rights were established. Though Piers Gaveston brought certain advantages to Knaresborough, he was generally unpopular, and few can have been sorry when, in May 1312, he was besieged in Scarborough Castle by rebellious barons and later beheaded near Warwick; his head was sent to the King.

EDWARD III

King Edward stayed in Knaresborough Castle several times, notably in January 1328 after his marriage to Queen Philippa in York. There are references to Edward III breeding horses in the 'Park de la Haye' (Haya Park) and hunting deer and boar in the Forest of Knaresborough. In 1355, he was attacked by a boar he had just wounded, and was thrown from his horse. His life was saved by Thomas Ingilby of Ripley Castle, who slew the animal; Ingilby later received a knighthood, and a boar's head was henceforth included in the Ingilby arms.

QUEEN PHILIPPA

Philippa of Hainault, a fifteen-year-old princess, was apparently tall, beautiful and graceful; she spoke both Flemish and French, and came to York to marry Edward III on 24 January 1328. The King brought Philippa to Knaresborough Castle for a brief honeymoon, appropriately enough, as he had granted her the 'Castle, Town, Forest and Honour of Knaresborough, of the value of £533 6s 8d' as part of the marriage settlement. Queen Philippa came here again, in 1332, taking a practical interest in

the administration of the town, as shown by the frequent references to her in local documents. She often accompanied the King on his travels, and was present at the defeat of the Scots at the Battle of Neville's Cross (1346) and the capture of Calais (1347), when she pleaded for the lives of the six burghers, shown in Rodin's marvellous sculpture in Calais (and its replica near the Houses of Parliament). Less well-known, is the fact that she successfully pleaded for the lives of the carpenters who had made a stand that collapsed at a tournament she attended in York. Though she never settled in Knaresborough, the Queen must have spent a lot of time here, sometimes with Edward and their children, including the two sons who became famous as the Black Prince and John of Gaunt. Of particular interest was the parish church, whose restoration and re-consecration she oversaw in 1343. She died in 1369. For many years, the castle displayed 'Queen Philippa's chest'. But her lasting memorial here is the parish church.

JOHN OF GAUNT

The fourth son of Edward III, so called because he was born to Queen Philippa and Edward III in Ghent in 1340. He was made Duke of Lancaster and became a renowned huntsman, especially in the forest of Knaresborough, with his castle in Haverah Park. He is said to have killed the last wolf in England in about 1380. Gaunt became one of the wealthiest men in England; in 1372 he was granted the Lordship of Knaresborough.

RICHARD II

Deposed by Henry Bolingbroke, son of John of Gaunt, whose lands he had confiscated, King Richard was imprisoned in various castles, including Knaresborough in 1399, shortly before his mysterious death in Pontefract Castle. According to the chronicler Hardynge.

> And to Knaresburgh after led was he,
> But to Pountefrete last, where he did dee

The tradition is that, he was imprisoned in Knaresborough, not in the castle dungeon, but under house-arrest in the King's Chamber.

JAMES I

When King James VI of Scotland acceded to the throne of England as James I, he would have passed through Knaresborough during the Royal Progress, travelling from Ripley on his way to York. The following year, 1604, he confirmed Knaresborough's Charter and, in 1616, readily gave permission to found a school here in his name, King James's School.

CHARLES I

His father, James I, granted him the lordship of Knaresborough in 1616, nine years before he was crowned King. The castle, and many Knaresborough people, remained loyal to him throughout the Civil War.

EDWARD VII

His coronation in 1902 was commemorated by Benjamin Woodward, joiner and undertaker, who named the house he built that year – No. 45 Kirkgate – 'Coronation Cottage', and added the coloured plaque of the King, still to be seen.

Knaresborough People

JOHN MONOCULUS

His Latin moniker means 'one eye'; he possibly won it because he had lost the other in battle. One of the first Lords of Knaresborough, he was the brother of Serlo de Burgh, founder of the castle, and married to Magdalen, an aunt of King Stephen. His son was Eustace fitz John, who was said to have generously sent a cartload of bread to the starving monks at Fountains abbey in 1133.

HUGH DE MORVILLE

Ringleader of the four knights who assassinated Thomas Becket on 29 December 1170. The four fled, and took refuge in Knaresborough Castle, where de Morville was constable. As part of his penance for the murder in Canterbury Cathedral, he apparently built the church at Hampsthwaite, which he dedicated to St Thomas Becket. Another condition for a pardon was that they each go on a pilgrimage to Jerusalem.

ST ROBERT OF KNARESBOROUGH

Knaresborough's once world-famous eccentric saint was born more prosaically Robert Flower in York in 1160. He came from a good family, his father and brother becoming mayors of York, but he chose instead to renounce his patrimony and, after a short time in the Cistercian abbey of Newminster in Northumberland, lead the ascetic life of a religious hermit. He wandered about the Knaresborough district, eventually settling in the riverside cave near Grimbald Bridge, which can still be seen. Robert lived on roots and barley bread, and drank only water. He grew his own crops and, according to legend, tamed stags and harnessed them to his plough. Latin texts in prose and verse tell his story, as well as fifteenth-century verse, which includes the lines:

To begge and brynge pore men of baile,
That was hys purpose principale.

His first home was a cave occupied by a knight on the banks of the Nidd, and was called St Giles' chapel. The knight soon moved out 'at the prompting of the devil', and went home to his wife and children. The writer of the piece, perhaps a misogynist, was obviously not impressed by this expression of familial devotion describing it as 'the return of a dog to his vomit'. There followed a period of itinerancy that found Robert running St Hilda's chapel at Rudfarlington, a post provided by a virtuous matron named Helena, but he was robbed there while meditating and relieved of 'hys bred, his chese, hys sustynance'. Somewhat aggrieved, he moved on to Spofforth, but could not bear the noise and clamour there, 'fearing lest the crowds which followed him should move him to vainglory', and so joined the monks

at Hedley, a cell of Holy Trinity priory in York. He thought his companions there 'fals and fekyll' and returned to St Hilda's, where his patroness built him a hut and a barn.

Because he befriended the poor and felons, he was often in trouble with the authorities. William de Stuteville, constable of Knaresborough, saw his house one day and cried: 'This is a hypocrite and a companion of thieves!' and bade his men 'dyng doune hys byggynge'. The homeless hermit returned through the forest to Knaresborough:

> To a chapel of syntt Gyle
> Byfor whare he had wouned a whyll
> That bygged was in tha buskes with in
> A lytell holett : he hyed hym in.

Robert's return to St Giles was met with further threats of eviction by de Stuteville. But Robert was in league with higher powers, which gave de Stuteville terrible nightmares: three men, 'blacker than ynd' woke him up: two of them harrowed his sides with burning pikes, while the third, a giant of a man, brandished two iron maces at his bedside: 'Take one of these weapons and defend thy neck, for the wrongs with which thou spitest the man of God'. William begged for mercy and promised to mend his ways.

> Roberd forgaff and William kissed
> And blythely with hys hand hym blyssed.

De Stuteville bestowed upon Robert all the land between the rock and Grimbald Kyrkstane, as well as two each of oxen, horses and cows. There were regular gifts and alms for the poor from Knaresborough Castle from then on.

Robert's brother, Walter, was mayor of York; he visited his hermit brother and tried to persuade him to join a monastery in order to enjoy the relative comforts there. When Robert refused, famously saying 'This is my resting-place forever : here will I dwell, for I have chosen it' Walter sent workmen from York who built a chapel in honour of the Holy Cross, adjoining the cave, and replaced the humble oratory of St Giles. William de Stuteville was succeeded by Brian de Lisle, who became a faithful friend of Robert. It was he who suggested to King John that he visit Robert. John made a pilgrimage to his cave in 1216, and was impressed by his piety; this was in spite of the fact that Robert, deep in prayer, had at first shown irritation at being disturbed. Finally Sir Brian interrupted him, saying: 'Brother Robert, rise quickly : Lo! The king is here who would speak with thee.' Robert stood, and then asked Sir Brian to point out to him which one was the King. Having picked up an ear of corn, he held it towards King John, and said: 'If thou be king, do thou create such a thing as this'. When the King could make no reply, he added, 'There is no King but one, that is God'. Some of the retinue regarded the hermit's behaviour as madness, but one replied that Robert was indeed wiser than they, since he was the servant of God in whom all is wisdom. Impressed by this piety, King John asked Robert what in the world he wished for; characteristically the hermit said that he had all he needed. His companion, Brother Ivo, promptly reminded him of the plight of the poor, and so Robert received as much of the nearby wood as he could till with one plough.

Robert was no fool. Once, while out collecting alms, he asked a man of wealth for a cow; he was fobbed off with a wild beast so vicious that it was uncontrollable. Robert took it and tamed it. To regain his reformed cow, the rich man had one of his servants pretend to be a cripple and beg for the beast. Robert saw through this guile and turned the servant into a real cripple until he confessed his deceit. On another occasion, Robert complained to the Lord of Knaresborough about the stags trampling down his corn; he was given permission to take as many as he liked and drove the stags submissively into his barn. The Lord slyly changed his mind, and allowed Robert to retain only three. Robert yoked the three to his plough.

Robert died in 1218, and the priory, later built on land given by King John, carried on the good works under Brother Ivo. His healing miracles continued to be associated with St Robert's tomb (probably confused with St Robert's Well), visited by so many, including Edward I from Knaresborough Castle. It was said that Robert of Knaresborough was one of the three most popular saints in Europe.

ROBERT DE NEVILLE

Vicar of Knaresborough in 1349 at the time of the Black Death. After ministering to his infected parishioners, he died of plague himself the following year, and was replaced by Jollan de Neville, possibly his brother, who was a farmer and served as vicar until 1354.

GEOFFREY CHAUCER

The poet had a connection with Knaresborough. In 1394, his sister-in-law, Catherine Swinford, married John of Gaunt, Lord of Knaresborough, who later appointed as constable of the castle a Thomas Chaucer – the son of the poet and Speaker of the House of Commons.

JOHN THE MASON

Founder and excavator of the chapel of Our Lady of the Crag in 1408. There is a legend that he made the chapel as a votive offering, following a miracle in the nearby quarry, when his young son was nearly killed by a falling rock. In his vision, he was pulled out of the way by the Virgin Mary.

THE PLUMPTON FAMILY

Lords of the Manor of Plumpton who enjoyed a long association with Knaresborough. Sir William Plumpton, whose son had been killed at the Battle of Towton in the War of the Roses (1461), was constable, seneschal and master forester. He lived at Wintringham Hall, having entered into a clandestine marriage in 1451 to Joan Wintringham and, in 1472, had to defend himself in court against 'unlawful intimacy, to the great peril of his soul and the grievous scandal of all the faithful'. Because the family became its patrons, St Edmund's chapel in the parish church was known as the Plumpton chapel until the seventeenth century.

JOHN LELAND

The antiquary of Henry VIII, who toured England noting places of interest including Knaresborough, which he visited around 1538. He observed that the 'river sides of Nidde

be well wooded above Knarresburg for 2 or 3 miles, forest full of lynge (heather), moors and mosses, with stony hills'.

GUY FAWKES

Born in York in 1570, Guy Fawkes came to live near Knaresborough in his late teens. This was when his widowed mother married Dennis Bainbridge of Scotton, a Catholic who lived in Percy House, Scotton, and also at Scotton Old Hall. Guy had been brought up a Protestant, but the illegal Catholic religion of his new relations, some living in Knaresborough itself, led to his conversion. The marriages of Guy's two sisters are recorded at Farnham parish church and, although he signed himself, 'Guye Fawkes of Scotton, gentle-man', in 1593, he moved south, and eventually joined the Spanish Army fighting in the Netherlands.

As Capt Guido Fawkes, he had a distinguished military record, and his expertise with explosives led the plotters to recruit him in their attempt to assassinate James I. It has been claimed that the plot was made around a table that was kept in a Knaresborough inn, but this is, in fact, an antique bought in modern times by the owner of Scotton Old Hall. It is true, however, that most of the conspirators had family connections with Lower Nidderdale. Guy Fawkes, calling himself Johnson, a servant to Thomas Percy, smuggled thirty-six barrels of gunpowder under the House of Lords, ready for its royal opening on 5 November 1605. Just before midnight, he was arrested, 'booted and spurred', ready to make his getaway, having on his person a watch, lantern, tinderbox and slow fuses. He was interviewed by King James in his bedchamber, taken to the Tower to be tortured, and finally 'hanged, drawn and quartered' as a traitor on 31 January 1606. Though he is still burnt in effigy on 5 November (Plot Night, as it is called in parts of Yorkshire), no guy is ever burnt at St Peter's, his old school in York, or on the public bonfire in Scotton.

THE COLLINS FAMILY

A distinguished family, with close associations with Knaresborough since the seventeenth century and mainly resident at Kirkman Bank and Knaresborough House. The Revd Thomas Collins was Knaresborough's longest-serving vicar, from 1735 to 1788. He was, for many years, a governor of King James's School, and knew characters such as Blind Jack and Eugene Aram. He is not to be confused with a later relation (also a Revd Thomas Collins), whose son, Tom Collins, a barrister, was first elected as a Conservative MP for Knaresborough in 1851, and who was soon nicknamed 'Noisy Tom' because of the constant interruptions he made in the House of Commons. Col W. F. Collins was a magistrate and chairman of the bench for twenty-five years. His wife, Lady Evelyn Collins, a cousin of Winston Churchill, served as chairman of the council and of the governors of Knaresborough Grammar School.

SIR HENRY SLINGSBY

The son of the other Sir Henry Slingsby and MP for Knaresborough in 1640. He was a colonel in the royalist army and confined, as punishment, by Cromwell, to within 5 miles of his home, Red House, in Hull. In 1654, he was implicated in a doomed Royalist conspiracy, fatefully meeting with around 100 rebelson Marston Moor. This rendezvous was no secret

to Cromwell, who condemned him to life in prison in Hull for his troubles. In reality, he was living on parole in a house in the city, but in 1658 was later charged with attempting to enlist the garrison in Hull. A charge of treason followed and he was sentenced to be hanged, drawn and quartered. Cromwell commuted it to beheading. A calm Sir Henry took to the scaffold on Tower Hill, telling the audience that he 'died for being an honest man, of which he was very glad, but sorry only that it was not for some more effectual service to his majesty'. Before his death, however, Sir Henry had been something of a parliamentary reformer. The result of his successful candidacy for MP for Knaresborough for the Long Parliament in 1640 was due in part to the longstanding tradition of providing copious free alcohol to potential voters. Slingsby moodily said of it, 'there is an ill custom at these elections to bestow wine in all the town, which cost me £16 at least, and many a man a broken pate'.

OLIVER CROMWELL
Although Cromwell was not present when his Parliamentarian forces took Knaresborough Castle in 1644, after his victory at Marston Moor he was remembered for his kindness to the widow of Colonel Townley, who had come to recover her Royalist husband's body from the battlefield. Cromwell later stayed in Knaresborough in 1648 when the castle was being officially dismantled. Cromwell House, in High Street, was largely rebuilt, but the floor of the bedroom where he slept was carefully retained. This was partly because of an

Practical Magick in Knaresborough do not end with Mother Shipton and the Dropping Well, as this picture of Practical Magick in Castlegate would appear to show.

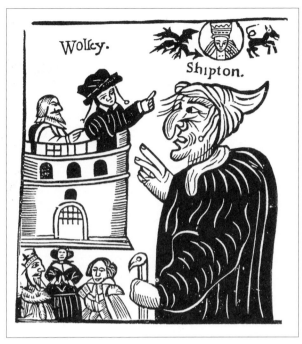

Various representations of Mother Shipton. The first is from a 1663 woodcut and shows the doomed Cardinal Wolsey at Cawood Castle, the closest he ever got to York.

eyewitness account by Eleanor Ellis, daughter of the house, who had taken up a warming-pan to air Cromwell's bed, then spied through the keyhole and observed him as he knelt in prayer.

EDMUND DEANE

Edmund Deane, a York doctor, praised the town as the ideal base for 'taking the waters' at the various wells in the district, principally those at what later developed into High and Low Harrogate. In his book *Spadacrene Anglica: The English Spaw, or the Glory of Knaresborough* (1626), Dr Deane says of what was then being called 'Knaresborough Spa':

> Both the Castle and the Towne are fenced on the south and west with the River Nidd, which is beautiful here with two faire bridges of stone. About the towne are divers fruitful valleys, well replenished with grasse, corne and wood. The waters there are wholesome and clear, the ayre dry and pure. In brief, there is nothing wanting that may fitly serve for good and commodious habitation, and the content and entertainment of strangers.

Deane lists the various diseases and conditions the Spa was famous for curing; they include: 'itches, scabs, morphews (a scurfy eruption), tetters (any of various skin diseases, such as eczema, psoriasis, or herpes, characterized by eruptions and itching), ringworms and the like, which are soone holpnen and cured by washing the parts ill-affected therewith'. Deane recommended that there be two 'capacious baths', one hot and one cold.

CELIA FIENNES

The intrepid lady who rode side-saddle through England, and was the first to visit every county in the land, reached Knaresborough in 1697/98. Describing Knaresborough on her extraordinary tour in *Through England on a Side-Saddle*, she admired 'the little houses ... all built in the rocks', the Crag Chapel, the castle ruins and a 'Cherry Garden with green walkes for the Company to walk in'. She went to Harrogate 'on a Common that belongs to Knaresborough, all mossy and wet'. She described the Stinking Spaw (the Old Sulphur Well) as 'not improperly term'd, for the Smell being so very strong and offensive I could not force my horse near the Well'. The waters were 'a good sort of Purge if you can hold your breath so as to drink them down'. She also visited the Dropping Well and St Mungo's Well at Copgrove.

DANIEL DEFOE

In 1717, he stayed in Knaresborough, and talks of the 'wonderful strangeness of this part' in *A Tour Through the Whole Island of Great Britain*. He later described how he had been out to visit the wells on Harrogate Stray, and been surprised at the large numbers visiting this 'most desolate out-of-the-world place', remarking how he had heard that 'men would only retire to it for religious mortifications, and to hate the world, but we found it was quite otherwise'.

MOTHER SHIPTON

Born in 1488 (predating Nostradamus by fifteen years) in a cave next to the River Nidd, the legendary Mother Shipton (née Ursula Southeil) is synonymous with Knaresborough, and the art of prophecy. Afflicted by what was probably scoliosis, and variously branded a witch and the Devil's daughter, her predictions have included the demise of Cardinal Wolsey, the Gunpowder Plot, the Great Fire of London, her own death, and, as yet

Two contrasting pictures of the hapless Eugene Aram.

unsuccessfully, the end of the world (1881 and 1991). The first account of her did not appear until 1641. This describes how, when living in York, she had predicted that the disgraced Cardinal Wolsey, who planned to be enthroned as Archbishop in 1530, would see York, but never reach the city. Wolsey got as far as Cawood Castle, and from the tower saw York minster in the distance, vowing he would have Mother Shipton burnt as a witch. He was arrested on a charge of high treason, and died on the journey south. This first printed version of the prophecies spread the fame of Mother Shipton throughout England. In 1667, a fictionalised account of her by Richard Head stated she had been born (after her mother had been seduced by the Devil in disguise) at Knaresborough, 'near the Dropping Well'. Head's publication contains the first of many fabricated prophecies attributed to Mother Shipton, all written after the events (e.g. the defeat of the Spanish Armada). Forgeries were taken a stage further by the Brighton bookseller Charles Hindley who, in 1873, confessed that he had made up prophecies about modern inventions and one that had caused much alarm:

> Then the world to an end shall come
> In eighteen hundred and eighty one

William Grainge noted that, in 1848, when the viaduct collapsed, locals had started saying that Mother Shipton had always predicted that 't' big brig across t' Nidd should tummle doon twice, an' stand fer ivver when built a third time' – a garbled version of which still survives, linked with the end of the world.

Until about 1908, a cottage near Low Bridge was regularly visited as the birthplace of Mother Shipton. The cave near the Dropping Well, though associated with her from Victorian times, was not publicised as the actual birthplace until about 1918. Outside Knaresborough, the prophetess became a figure of folklore. For around 200 years, she was familiar as a puppet who smoked a real pipe. A moth has been named after her: *callistege mi*, which apparently bears a profile of a hag's head on each wing. She became a popular character in pantomime, her part played by men, including David Garrick in 1759, making her the first real pantomime dame. By 1770, at Covent Garden, Mother Shipton's spectacular transformation scenes also made her the first fairy godmother. Despite claims by numerous other towns in the UK, this is where we like to think Mother Shipton was born, to Agatha, during a violent thunderstorm. The Shiptons continue to fascinate to this day, with the comparatively neglected husband, Tobias Shipton, celebrated by Middlesbrough poet Bob Beagrie in his 2010 poem, 'The Seer Sung Husband'.

EUGENE ARAM

Eugene Aram was born at Ramsgill in Nidderdale in 1704. In 1734, he moved to Knaresborough and set up a school at the top of High Street, in White Horse Yard, now Park Square. A self-educated scholar and linguist, Aram was versed in Latin, Greek, Celtic and Hebrew, as well as in advanced mathematics. Things took a turn for the worst when Aram was implicated in a fraudulent scheme along with a flax-dresser, Richard Houseman, and a young cordwainer, Daniel Clark. On 7 February 1744, Clark disappeared; it was assumed that he had absconded with some valuables. Aram paid off his debts and left

Knaresborough. However, that was not the end of the matter. In August 1758, a skeleton was unearthed on Thistle Hill. Houseman, accused of Clark's murder, denied that the remains were Clark's: 'this is no more Clark's bone than it is mine'. He eventually confessed that Clark was, in fact, buried in St Robert's Cave; Houseman alleged that he had seen Aram strike Clark. Aram was traced to King's Lynn, where he was an usher in a school; he was arrested and brought back to be imprisoned in York Castle. A sophisticated defence speech failed to save him, and he was found guilty at York Assizes. On 6 August 1759, he was sentenced to swing in York, and later hung on the gibbet in Knaresborough, near the Mother Shipton Inn. Body parts were stolen as relics. Two writers made Eugene Aram well known to Victorians – Thomas Hood, in *The Dream of Eugene Aram: Murderer* (1831), which vividly describes his guilty conscience, and Edward George Bulwer (Lord) Lytton in a work of pure fiction, *Eugene Aram*, which attempts to exonerate him. The 1875 *Memoirs of the Celebrated Eugene Aram With the Gleamings After Eugene Aram Unexpectedly Gathered After the Publication of His Memoirs,* by Norrisson Cavendish Scatcherd and Thomas Hood, introduces a disaffected and hard up Mrs Aram to the witness box. She was also infatuated with Houseman.

until her pecuniary resources failed her, she was mute; and then, after some grumbling, she turned the full tide of her wrath on her unfortunate husband. Her gossip, from the account we have of it, was that of a faithless, incredible, and frivolous woman. As to the murder, she could, at most, only speak from suspicion.

BLIND JACK

The nickname of John Metcalf, who was born in 1717 in a cottage (demolished in about 1768) near the parish church and was a true jack of all trades. He went to school aged four, but at the age of six he was afflicted by smallpox, which left him completely blind. An intelligent boy with prodigious determination and energy, he led an active life tree-climbing, swimming, hunting and gambling. At fifteen, he was appointed fiddler at the Queen's Head in High Harrogate. Later, he earned money as a guide (especially at night-time), eloped with Dolly Benson, daughter of the landlord of the Royal Oak (later the Granby) and, in 1745, marched as a musician to Scotland, leading Capt Thornton's 'Yorkshire Blues' to fight Bonnie Prince Charlie's rebels.

Blind Jack is best known for his work as a pioneer of road building. His extensive travels, and the stagecoach he ran between York and Knaresborough, had acquainted him with the appalling state of English roads. Soon, after a new Turnpike Act in 1752, he obtained a contract for building (with his gang of workmen) a 3 mile stretch of road between Ferrensby and Minskip. Then he built part of the road from Knaresborough to Harrogate, including a bridge over the Starbeck, and went on to complete around 180 miles of road in Yorkshire, Lancashire and Derbyshire. The specially constructed viameter he used to measure his roads can be seen in the Courthouse Museum. Following Dolly's death in 1778, he went to live with his married daughter in Spofforth. Here, after many active years in business and as a violinplayer, he died in 1810, leaving behind four children, twenty

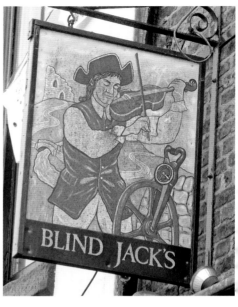

Above: Blind Jack alive and well on a pub sign and Renaissance window.

Left: A picture from 1810 of Blind Jack, emphasising his 6'2" height.

grandchildren and ninety great- and great-great grandchildren. A tombstone in Spofforth churchyard pays tribute to the remarkable achievements of 'Blind Jack of Knaresborough', and he was commemorated with a bronze statue by Barbara Asquith in Knaresborough marketplace in 2009.

ELY HARGROVE

Knaresborough's first local historian, author of *The History of the Castle, Town and Forest of Knaresborough, with Harrogate and its Medicinal Waters*. This was published in 1775, and went through several editions, with slight updating, until the seventh edition in 1832. Hargrove's history contains much valuable information on the town, where he ran his High Street printer's and bookshop, later Parr's. He died in 1818, aged seventy-seven; his tomb can be seen near the chancel door of St John's parish church.

DAVID LEWIS

David Lewis was a 'poor gardener' in Knaresborough, as well as being a writer and poet. He is the author of *Beauties of Harrogate and Knaresborough*, a brochure printed in Ripon in 1798. He penned these lines about Knaresborough:

> Knaresbro' mountain-mantling town
> On field and flood both looking down.
> From its north and eastern brows,
> We see beyond the Vale of Ouse;
> Yellow crops and meadows green,
> Trees and towns and woods between.

He lived at Belmont Farm (where he planted the fir trees), which was halfway between Forest Lane Head (the Golf House) and the railway line passing through Belmont Wood between Knaresborough and Starbeck, about 400 yards in front of the Golf House. Other works include 'Elegy on the Death of a Frog', 'The Sweeper and Thieves,' and 'The Pocket-Books', three short poems in dialect. *The Landscape and Other Poems* is a volume of 100 pages, published at York in 1815, along with *A Week at Harrogate, in a Series of Letters*. Other fragments include: 'The Knaresbrough Electikon. A Ballad', signed D. L., with eight four-line verses and dated 1805, 'Verses to the Memory of the late Sir Thomas Turner Slingsby', 'Baronet, of Scriven: Who Died March 20 1806', signed D. Lewis and printed by Hargrove & Sons, Knaresbrough. 'Peace an Ode', 'A Yorkshire Plough-Boy' and 'Knafredsbro,' from 24 October 1801,are each seven stanzas and were printed by Broadbelt.

'Ode', signed D. L., Knaresbro is from 6 January 1804, printed by John Heeley. 'An Ode to the Moon', by D. Lewis, is structured in three-line stanzas, forty-two lines in all.

There are some biographical allusions to the loss of his parents, the dishonesty of his relations, and the kindness of Sir Thomas Turner Slingsby in the verses to that baronet's memory. An edition of Lewis' collected works was published by the *Herald* office in York in 1815. Lewis died in 1858.

LORD KNARESBOROUGH

A fine portrait of Lord Knaresborough.

SIR CHARLES SLINGSBY

The last direct male descendant in the Slingsby line, Sir Charles of Scriven Hall was a keen huntsman, and, unfortunately, is especially remembered for his tragic death during the York and Ainsty fox hunt on 4 February 1869. A fox was spotted at Monkton Whin and pursued for a full hour. When Slingsby crossed the River Ure, near Newby Hall at Stainley House, between Harrogate and Ripon, in a flat-bottomed boat used for maintenance at the hall, the horses in the crowded ferry-boat became restless. Saltfish, Slingsby's horse, kicked the horse of Sir George Wombell. Saltfish leapt from the boat, dragging Slingsby with him. The boat capsized, and within minutes eight horses and six men, including Sir Charles, were drowned, despite efforts to swim to the shore. Saltfish survived. The funeral in the parish church was the largest in Knaresborough's history, with at least 1,500 mourners arriving on foot, as well as ten coaches of dignitaries and fifty-three private carriages. In his memory, Sir Charles Slingsby's sister, Emma Louise, donated the tomb in the Slingsby chapel, with its fine recumbent effigy, sculpted by Boehm, and the west window.

Lt D. G. TURNBULL

This brave pilot in the Royal Flying Corps was killed on 15 April 1917, when delivering a newly built plane from Coventry to Ripon. He broke his journey in Knaresborough, somewhat disorientated because of heavy showers. He landed in a field on Crag Top,

showed local boys his map, then asked them to help him to turn the plane around. When he took off, he caught a tree on the edge of the crag, and crashed into the Nidd near Chaffey Dam. There is a memorial plaque in the parish church.

THE SLINGSBY BABY CASE
This was the popular name given to the lawsuits involving a member of the Slingsby family and his American wife, claiming that an adopted child was their own, and so legally entitled to the Slingsby inheritance. They lost their case and, in 1916, the Slingsby Estate, covering much of Knaresborough, was sold off by public auction. The Dropping Well Estate, for example, was bought by J. W. Simpson.

LORD KNARESBOROUGH
Henry Meysey Meysey-Thompson, first Baron Knaresborough (1845–1929) was a liberal politician who sat in the Commons between 1880 and 1905, when he was raised to the peerage as Baron Knaresborough. Meysey-Thompson was born at Kirby Hall, near Great Ouseburn. He was educated at Eton and at Trinity College, Cambridge, where he won a blue in athletics and was awarded his BA in 1868. He became a private secretary to Gladstone.

When Meysey-Thompson was elevated to the peerage in 1906, he announced that he would take Lord Knaresborough as his title. This was partly because he had been elected an MP for Knaresborough in 1880; however, he had actually been unseated following a Conservative petition alleging bribery by the Liberals. There was an immediate outcry from the people of Knaresborough, with the chairman of the KUDC appealing (in vain) to Sir Henry not to use this title, as he had no family connection with the town.

SIR HAROLD MACKINTOSH
The famous toffee magnate from Halifax lived in Conyngham Hall from 1924 to 1942, breeding prize dairy cattle in the extensive grounds. He presented a small wooded area in nearby Bilton Fields to the people of Knaresborough, nicknamed 'Toffee Park'. He was, of course, the son of John Mackintosh.

John and Violet Mackintosh set up their business in a pastry shop in King Cross Lane, Halifax, in 1890, financing the company with the £100 they had saved between them. Their first launch was 'Mackintosh's Celebrated Toffee', a winning mixture of English butterscotch and American caramel. Mackintosh was nothing if not innovative – he exploited sampling to the full. One week he was inviting customers to come and taste a sample for free, the next he was urging them to come again and 'eat it at your expense'. Modest too; by 1896 Mackintosh was styling himself as 'Toffee King'. Mackintosh was keen to develop his export trade, but this was not without its problems. In mainland Europe, potential customers confused toffee with coffee, and poured boiling water on it 'with unsatisfactory results'. In America, the extreme variations in climate wreaked havoc and, depending on the time of year, toffee was melting in some states and was rock hard in others. Notwithstanding, this is how he self-effacingly heralded his entry into the American market: 'I am John Mackintosh, the Toffee King, Sovereign of Pleasure, Emperor of Joy. My old English candy tickles my millions of subjects ... I was crowned by the lovers of good things to eat ... I am the world's largest consumer of butter, my own herd of prize cattle graze on the Yorkshire

Heath Robinson's take on
Mackintosh's Toffee Town.

hills. I buy sugar by the trainload. I am John Mackintosh, Toffee King of England and I rule alone.' His eloquence and industry were rewarded with ample success, even in intractable markets like China, where the toffee he supplied was pink.

In 1927, chocolate coated 'Toffee Deluxe' was launched, followed by 'Mackintosh Chocolate' in 1924. John's son, Harold Mackintosh, later 1st Viscount Mackintosh of Halifax, took over in 1920. He developed the Methodist principles on which the firm had been founded, notably enlightened management and good labour relations. In 1932, he bought the A. J. Caley Norwich confectionery company from Unilever. This expanded their range of products and led to the launch of blockbuster products such as Quality Street in 1936 and Rolo in 1938.

The Quality Street name was inspired by J. M. Barrie's *Peter Pan*. 'Major Quality' and 'Miss Sweetly' owe their lives to the play's protagonists, and appeared on all Quality Street packaging and advertising, until 2000. They, in turn, were actually modeled by Iris and Tony Coles, the children of Sydney Coles who created the brand's image. Mackintosh took

THE
W. H. SMITH & SON
AMATEUR
DRAMATIC SOCIETY

presents

Quality Street

at the

CRIPPLEGATE THEATRE
GOLDEN LANE, E.C.1

on

WEDNESDAY, THURSDAY and FRIDAY

June 1, 2 and 3

Christmas time is "Carnival" time

Mackintosh's

TOFFEE DE LUXE

Vivid 1950s advertising for Mackintosh's and for *Quality Street*, The Play.

an advertisement on the front page of the *Daily Mail*, on 2 May 1936: 'An introduction to Quality Street'. It shows Miss Sweetly tempting Major Quality with a tin of the sweets. 'Sweets to the sweet, Miss Sweetly?', asks the Major, to which she coyly replies, 'Spare my blushes Major Quality, feast your eyes rather on this sumptuous array of toffees and chocolates ... 'tis the most momentous thing that has yet happened in the world of sweetness.' She gives him a toffee creme brazil, which he declares 'a veritable triumph!' Some 7 million Quality Street chocolates are now produced every day, the most popular out of the seventeen being 'the Purple One'. The slogan for the trade in the 1930s was, 'put your shop in Quality Street by putting Quality Street in your shop.' Heath Robinson and Mabel Lucie Atwell were among the artists commissioned to draw for Mackintosh, most famously for the Toffee Town advertisements.

THE BLIND FIDDLER
Blind Jack was not the only blind musician in Knaresborough's history and Mother Shipton was not the only gifted old lady to come from the town. This fiddler used to play in the entrance to the old Post Office in Harrogate's James Street; her name is not known, but she came from Knaresborough.

'GINGER' LACEY
Born in Wetherby, but educated at King James's Grammar School (1927–33), James Harry

Lacey was one of the best-known aces of the Second World War, shooting down more enemy planes in the Battle of Britain than any other pilot – twenty-eight enemy aircraft destroyed, plus five probables and nine damaged. He was awarded ten medals, including the DFM and bar, and the Croix de Guerre.

'BUNNY' CLAYTON

Educated at King James's between 1931 and 1938, Bernard Clayton was a bomber pilot in the Second World War; his decorations include the DFC, CGM and DSO. He survived the war, but was tragically killed on a test flight in 1951.

NANCY BUCKLE

Thomas Hill, of the House in the Rock, is the great-great-great-great-grandfather of Nancy Buckle, who was Knaresborough's first (and only so far) female town crier. As a teenager, Nancy auditioned for, and was accepted into, the Bluebell Showgirls. Her aunt with whom she lived refused to sign the papers she needed to allow her to travel to Las Vegas with them.

MAGNA CARTA

The folk rock group formed in 1969. Their guitarist and vocalist, Tom Hoy, lives in Knaresborough. Before joining Magna Carta, Tom Hoy was with the Natural Acoustic Band.

Above left: The blind fiddler from Knaresborough, performing in Harrogate.

Above right: The Woolley Headed Boy – a guide at the House of the Rock around 1795.

Miscellany

One of the many buildings in Knaresborough redecorated to celebrate Le Grand Départ of the Tour de France 2014. This is the Stables Holiday homes in Bourne End.

A Knaresborough Old Bank proof with the pencilled date of 1839.

KNARESBOROUGH GEOLOGY

Older buildings, such as the castle and the parish church, are built from the magnesium limestone on which the town lies. This, however, only lasted until the eighteenth century, when the stone was either depleted or became too expensive and difficult to extract. Buildings since then were made largely from brick and sandstone.

THE KNARESBOROUGH CROSS

To see the Knaresborough Cross, you have to visit St Peter's church at East Marton, as it was taken there by the Roundell family when they left Knaresborough in the eighteenth century. Although only the middle section survives, it is a good example of Viking-style carving and evidence of early Christianity in Knaresborough.

THE KNARESBOROUGH SURNAME

The earliest record of a 'Knaresborough' was Roger de Knaresborough, in relation to a grant made to Fountains abbey over an irregular marriage to a Plumpton in 1451. A John Knaresborough born at Ferrensby in 1672 was educated at Douai, in northern France, as a Catholic priest. He was later chaplain at Burton Constable, moving to York where he died in 1724. Don Miguel de Knaresburgh is mentioned in 1783 by Hargrove. A merchant and colonel in the militia, he encountered one William Ackroyd, a lieutenant in the Royal Navy, at a ball in Havannah en route back to Knaresborough, also (astonishingly) from Knaresborough.

QUARRELS

Crossbow bolts, from the Latin *quadrellus* (square-shaped). Made from iron ore smelted in Knaresborough Forest, these were exported from Knaresborough Castle in great quantities during the reign of King John. In 1213, Brian de Lisle sent 3,000 quarrels to Portsmouth and 10,000 to Poole to equip the emergent Royal Navy. In the previous year, 62,000 quarrels had been sent from Knaresborough Castle, costing £46 4s 8d. Then, in 1214, King John ordered as many as possible to be sent to Portsmouth, with 1,000 retained for the defence of Knaresborough. These thirteenth-century munitions were made, or at least finished off, in the fifteen small forges found during the castle excavations.

WITCHCRAFT

The font cover is evidence of belief in witches, once locked into place to prevent holy water from being stolen. An example of such theft is the case of a Knaresborough schoolmaster, John Steward, who, in 1510, was arrested and accused by an ecclesiastical court in York of stealing holy water and using it to baptise a cockerel, cat and other creatures, and of conspiring to seek buried treasure by means of witchcraft. No other individuals in Knaresborough are recorded as being suspected witches, and Mother Shipton, in spite of Wolsey's threat to have her burnt, and later fiction by Richard Head, has nearly always been presented as a prophetess or Sybil, rather than a witch. The Oldest Chemist's Shop sold quills of quicksilver (mercury), to be carried on the person to ward off evil spirits, in the 1700s.

PARLIAMENTARY ELECTIONS

Knaresborough had the right to return two MPs from the days of Mary Tudor, in 1553, until 1867, when the Great Reform Act reduced the number to one. The first two MPs were Reginald Beisley and Ralph Scrope, returned by a very small electorate, as voting rights in the early days were only held by owners of burgage houses. Even by 1867, the number of voters had risen only to around 270. Small though these numbers were, the elections were often hotly contested. Voters were bribed with drink and plied with dinners, fights broke out, and the results were bitterly disputed. The two rival factions in the Civil War were represented by a succession of MPs in several Parliaments – a Slingsby for the Royalists and a Stockdale for the Parliamentarians. Rivalries continued to flare up. In the aborted elections of 1804, for example, a Knaresborough mob insulted and pelted the landowner, Sir John Ingilby, took staves from the constables, and dragged one down to the river, threatening to drown him. Rather more peaceful scenes in the marketplace centered around the election speeches from the balcony of the old town hall. In 1865, Isaac Holden, the Liberal textile magnate and Methodist philanthropist, beat the Conservative – Tom Collins – though the poll was topped by the popular Conservative, Basil Woodd, who was elected five times. In 1885, Knaresborough was disfranchised, as its population was below the required 15,000. During its existence as an electoral borough, it had returned 187 members to the Commons. In 1997, Knaresborough recovered its right to an MP, with the creation of the new constituency of Harrogate and Knaresborough.

KNARESBOROUGH CRIME

Knaresborough, like anywhere else, had its fair share of crime, petty, and otherwise. 'Woodland' offences were quite common, with offenders cutting off branches of evergreen in winter to feed sheep and cattle. Holly branches were particularly popular, with fines for offenders up to 1s but sometimes as much as 5s. In 1611, fifty people were each fined 3s 4d for pinching acorns in Swindon Wood, near Pannal, while scrumpers (apple thieves) were fined between 1s and 3s 4d. Fines were handed down to offenders pasturing sheep in Oakdene and Harlow, and for cutting maple holly in Bilton Park. In 1518, a number of men were fined 6s 8d or 10s for hunting in Haverah Park with greyhounds and bows and arrows. Market offences included forestalling and regrating; the former involved buying goods intended for market before they reached it; the latter, reselling goods bought at market within 4 miles of the market. In 1518, John Slingsby of Knaresborough was fined 1s 8d 'for regrating and forestalling the King's market there by buying a horse-load of salmon'. To regulate produce, each town had officers such as an ale taster, bread taster and inspector of hides.

Sanitation, or the lack of it, was a fertile source of litigation. Thomas Knaresborough was up before the court in 1511 and 1512, for not scouring the drainage ditches, which bordered his house in the marketplace. In 1562, John Dearluf was ordered to remove the dunghill in front of his house before Martinmas (11 November) or incur a fine of 2s. The dunghill stayed put, so he was in court again in April, with an order to remove it before Lammas (August 1) or face a fine of 6s 8d. The same court ordered three men to clear dunghills in front of their houses in the marketplace and clean the street. Dunghills

had to go, and an order to that effect was issued in April 1567. In 1640, John Bywatter was fined 10s because his 'privie [was] annoying his neighbours'. In 1561, a rule was made protecting the water supply: 'No one to wash fish in the Stock Well.'

Gambling was officially frowned upon. In 1561, Thomas Smythe and John Fawcede of Knaresborough were each fined 6s 8d for playing 'various illegal games'. In 1612, Richard Anderson incurred a 1s fine for keeping a 'house of unlawful games', in which 'men play with playing cards'. 'Behaving badly towards their neighbours at night' was an early form of antisocial behaviour and brought many an inebriated man before the courts. In 1612, John Dearlove of Knaresborough was fined 3s 4d for 'walking about illegally at night and abusing the constable'. 1525 saw Richard Hooper being ordered to stay at home every night after 9 o'clock, unless he had a 'legitimate and necessary cause' to be out.

In 1561, the wife of John Slater 'shall not Skalde any more frome henceforth amonge her neighbours or face a 6s 8d fine for each offence. The wife of John Hill, a notorious defamer and scold was fined 1s 8d in 1563. However, in 1562, John Stewarde was fined 1s 8d for being 'a common chatterer and scandaliser of his neighbours, to their great harm'.

Today, being charged with the offence of being 'common milkers of other men's cows' would assume some degree of euphemism. Not so in 1586, when Jane Smythe and her daughter were convicted of just that in the forest around Pannal. They were evicted from their house, while residents of the village were prohibited from sheltering them on pain of a 20s fine. In 1513, John Lax of Harrogate was found guilty of keeping a *porcum irracionabilem,* which choked William Benson's lamb.

WILLS AND INVENTORIES

Wills were not without their interest. In 1600, Thomas Hill of Knaresborough left the following to his maid, Anne Redshaw: a young heifer, three sheep, a swarm of bees, a mattress and bedding, a stool, table, candlestick, kettle, pans, saucers, bowls and other small things. Clothes were highly valued. In 1617, William Flint of Knaresborough left 'to my brother Robert my best suit of apparel, my doe-skinned doublet, my buckskin breeches and my coat; to my sister Jane's husband my other doublet and my clothe jerkin and breeches'. Illegitimate children were not always left out from the final cut. In 1590, John Yeadon of Knaresborough left 'to Thomas Yeadon alias Lister, my base begotten son, £5 and my sword'.

The 1686 inventory of Peter Benson of Knaresborough show him to be an exclusively arable farmer, the only one of any importance in the town. His inventory reveals that he had no oxen, with horses doing the ploughing: 2 cows £6; 6 horses £20; 1 pig £2; hay £10 16s; 360 stooks of hard corn £35; 220 stooks of barley £15; oats and beans £2; 2 carts, 1 plough, 1 pair of harrows, yoke, team and other gear £6; total £96. In 1661, Barbara Lewis of Knaresborough had £164 worth of inventory: 4 oxen; 3 cows, 3 mares; 1 nag; 1 foal; 58 sheep (£14); 15 pigs; 90 stooks of hard corn; 10 acres of barley; hay; 4 quarters of malt; 6 of oats; 19 bushels of peas; 4 of wheat; 2 of maslin (mixed wheat and rye); wain, coup and husbandry gear.

THE HEARTH TAX

The returns of the hearth tax give an interesting insight on the housing situation in any town or city. The 1664 returns for Knaresborough show 156 houses in total, seventy-nine of which had just the one hearth; forty had two; twenty three had three; four had four; four

Above left: Knaresborough Bouquet, with unquestionable endorsements in 1890.

Above right: Knaresborough Through Time, published in 2010 is still a local bestseller. Co-author Mark Sunderland did all the superb modern photography operating, from his studio in Briggate. To see more examples of his stunning photography and other books he has co-authored, go to www.marksunderland.com.

had five; five had six and one had over six. This gave a total of 308 hearths in the town. To put some flesh on the figures, the largest house in Knaresborough was owned by Richard Rhodes with fourteen hearths; Sir John Hewley could boast five hearths at his lodge in Haya Park; Simon Warner, dyer and maltster, had four, while the vicar, Matthew Booth, had three.

LIQUORICE

Liquorice was once grown and sold in Knaresborough, possibly having been introduced by the Trinitarian friars in medieval times. Its abundance in the fields around Knaresborough was noted by Camden towards the end of the sixteenth century. According to Hargrove, the last of the small enclosures in which liquorice was grown was one on Waterside, whose owner, Simon Warner, died in 1683.

POPULATION

In 1831, the downturn in the linen industry was part of the cause of decline of population for Knaresborough and Scriven, from 6,894 to 5,809 ten years later. There was a rise in 1851 to 6,292, but much of this can be accounted for by an influx of 241 labourers (and their families) to work on the railway. Later figures are:

Year	Population
1861	6,274
1871	6,178
1881	6,496
1891	5,385
1901	5,102
1911	5,315

Parish boundary changes in 1882 account for the 17 per cent fall between 1881 and 1891; housing developments are responsible for much of the growth from 1871 to 1881; the fall in 1891 is due to the agricultural depression that drove many from the land. The population in 2011 was 15,484.

NEWSPAPERS

In the eighteenth century, the news from Knaresborough was published in such papers as the *York Courant* and the *Leeds Intelligencer*. By the nineteenth century, the town was printing its own newspaper with a cover price of 1d: *The Northern Luminary and Knaresborough Independent Press*, claimed a greater circulation than any in the district, including the papers in Harrogate. *The Knaresborough Post* was first published in 1863 and, in the early 1900s, there was the *Knaresborough Guardian*.

THE WORKHOUSE

The first Knaresborough workhouse was a three-storey building in front of the parish church, opened in 1737 to accommodate about forty paupers. They were looked after by a master, who was paid £26 15s a year 'to take care of the Poor finding them Meat, Drink and Fire. Having the Benefit of Work done by the Paupers.' The workhouse inmates wove flax. In 1793, William Borrow, the master, complained of the popularity of the workhouse in his report to his superiors: 'Gentlemen, I think they come from all parts of the world to Knaresborough, for they know where they get much made on. Pox take 'em all!' Conditions, though, were harsh, and food poor – porridge, broth, suet pudding, and little meat. Some improvement occurred when a new workhouse was opened in Stockwell Road in 1858.

A report from the early years of the next century shows that 'The County Poor Law Institution, Knaresborough' had a total of 310 residents: '59 infirm men, 36 infirm women, 47 sick males, 66 sick females, 8 maternity cases, 17 children under three, 75 in the casual wards.' This shows that the workhouse – locally known as 't' Grubber' – was well on the way to becoming a hospital, and was used as such during the First World War. Later adapted as a geriatric unit, Knaresborough Hospital seemed to have a future, and externally its 1858 architecture was attractive, having been designed in mock Tudor style by Isaac Shutt,

architect of the Harrogate Royal pump room. However, in spite of protests, Harrogate Borough Council recklessly authorised its demolition in 1996.

A parliamentary report in 1834 included a description of the Starbeck, Knaresborough and Scriven workhouses, based on information provided at a meeting with local officials. Here are some extracts:

No work in any of the three workhouses, except that at Harrogate they have a garden nearly an acre in extent, which the inmates cultivate. There are no able-bodied men in Knaresborough workhouse; only two in Scriven workhouse; and three in Harrogate. No distinction in fare, except that one man in Harrogate workhouse who is worked hard at a coachmaker's has meat every day; the others in Harrogate and Scriven workhouses have meat four days a week; in Knaresborough they give meat three days a week; the other days, puddings and rice-milk and broth ... for breakfast and supper, milk-porridge and meal. No separation of the sexes in the three workhouses, except in the sleeping-rooms, which are on separate floors. The expense of maintenance in Harrogate for all above 10 years of age is 2s 11d per head per week, and under 10 one-half; this has been the average for five years. In Scriven, the average, including children, is 2s 7d. In Knaresborough they have a sick room, into which the paupers who die are removed; the other workhouses have not such accommodation... Mr. Peacock (Harrogate) thinks that if they had 5 or 6 acres of land they might profitably employ the paupers in its cultivation; this would not do for the other two townships, they say, because the paupers there are chiefly weavers. The children in Knaresborough and Scriven are sent to the national school. At Harrogate they have established a little school a short time ago, of which a pauper woman is the teacher, and which the master thinks preferable to sending them to the national school, which they are not sure they will always reach. The masters (of workhouses) think it would be hard to forbid tobacco to the old men and tea to the old women; but it is generally thought there would be no objection to a regulation forbidding the paupers to leave the walls of the workhouse, particularly if there be a garden attached. At Harrogate, the master when he sends the children to the Sunday school sends a note with them, mentioning the time of their departure, and the master of the Sunday school sends a note back with an account of their behaviour, and if not good, the defaulters go without dinner. None of the workhouses are incorporated; but to Harrogate eighteen other townships contribute 5s a year, and pay for each pauper what it costs the establishment, generally 2s 11d per head per week. In all the three workhouses there is, however, so little restraint that when a man gets in he seldom leaves. Mr. Peacock mentions an instance of a man who refused to work and was prohibited food, and on his going before the magistrates was committed to the house of correction, and has never since applied for relief. Though the idea is new to the gentlemen present, their prevailing opinion is, that an enactment prohibiting relief to the able-bodied.

The 1881 Census gives us a fascinating insight into the workhouse for that year. The 148 inmates include forty-seven from Knaresborough itself, with others from as far afield as Scotland and Ireland; a number of others originated from Harrogate, Killinghall, Hampsthwaite, Scotton, Darley, Ripley, Whixley, Scriven, Bishop Monkton and Plompton.

Of the Knaresborough inmates, twelve were scholars (schoolboys and school girls), fifteen were in the linen industry, three were imbeciles or idiots. The eldest inmate was eighty-five, the youngest three months. Sixty-four were female (43 per cent); thirty-seven (25 per cent) were infants or children.

THE KNARESBOROUGH VOLUNTEERS

The best-known body of voluntary soldiers that formed a militia were those led by Capt William Thornton and 'Blind Jack' during the 1745 Jacobite Rebellion. Though these have sometimes been called 'The Knaresborough Volunteers', the title was later officially given to a local army raised in 1794, in response to the threat following the French Revolution. On 4 July 1795, there was a gathering in Knaresborough Town Hall, where, after 'an elegant breakfast', Lady Slingsby presented the colours to Capt Robinson. The Knaresborough Volunteers were never called to action, but were mobilised on two occasions.

THE FORT MONTAGUE BANK

A 5½d skit note, dated 1806 and issued by Robert Hill, came up for auction in 2011. Also in the lot were the copper printing plates for the above, and a 5½d skit note unissued, but with the date of 1832 pencilled in. Knaresborough Old Bank was represented with a note bearing the pencilled-in date of 1839 for Harrison Jnr & Wood.

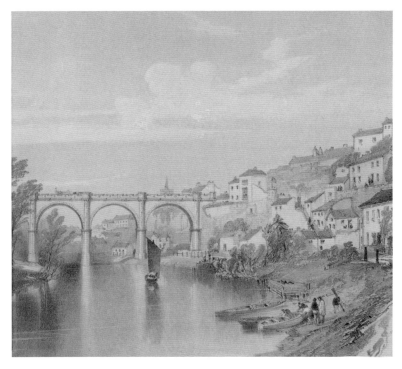

One of the first views of Knaresborough after the viaduct was built. The 1851 lithograph is by K. O. Hodgson and J. C. Bourne.

Two modern-day railway posters on display at Knaresborough railway station graphically promoting the town.

The unusual signal box at Knaresborough station.

THE PENNY CLUB

Founded in 1808, this charity provided the poor of Knaresborough with blankets, with subscribers paying 1d per week. By 1831, the club had raised £2,000 and the number of persons given free blankets stood at 6,435. Later it became known as the Blanket Club, and was in operation until the First World War. There was also a Clothing Club in the early 1900s, when the vicar, Revd W. E. Hancock, was chairman.

THE FEMALE SOCIETY

This was a Knaresborough charity started in 1809 to 'afford a comfortable and necessary relief to lying-in women' (expectant mothers). Run by a committee of twelve, the Female Society provided gruel, bread and coals for a month, together with linen and clothes for the newborn child.

POSTAL SERVICES

Names of a few of Knaresborough's early postmasters have come down to us – Stephen Parr, for example, a schoolmaster and trustee of the 1815 Methodist chapel, and Mrs Henrietta Parr, said to have been Britain's first postmistress. The first known post office was the building at the top of Kirkgate, which later became a pork butchers (Zisler's, then Holch's, now Robinson's). By late Victorian times, there was an efficient office in Knaresborough, run by postmaster Charles Blenkhorn, the boatman and landlord of the World's End. He sold stamps and postal orders, issued licenses, took in savings and handled telegrams. Long-serving postmen, such as Thomas Thorpe (from 1830) and John Patrick (from 1895), could deliver letters up to three times a day, and there were three collections from the main pillar boxes in High Street and the marketplace, with one on Sundays.

NIGHT POLICEMEN

One of the first acts in 1823 of the Improvement Commissioners – a crude form of local government – was to appoint six watchman to serve as night policemen during the winter evenings. They were each issued with an overcoat, an oilcloth cape and a pair of gaters, and pay was 11s per week for the policemen, 14s for the captain of the watch. Initially, they called out the time throughout the night, but this early version of the speaking clock was soon abandoned. Inebriation among the policemen was a recurring problem, and led to the appointment of a superintendent constable in 1838, who was paid a £65 salary, plus expenses and accommodation.

RAILWAYS

In 1819, a committee was set up to produce *The Report of the Knaresborough Railway*, envisaging what would have been perhaps the earliest line in the country to transport flax, linen, timber, coal, limestone, etc., as well as passengers. Since insufficient investment was available, the first railway to reach Knaresborough was somewhat late, and did not arrive until 30 October 1848. This line from York was forced to stop at a temporary station at Haya Park, because the viaduct across the Nidd collapsed just before completion, in 1848. The following year, the tunnel under High Street was finished by George Wilson and his 270 workmen. After the viaduct was rebuilt in 1851, the line extended as far as Starbeck, with another line going through to Harrogate by 1863. Knaresborough station

was completed in 1865, and further developed in 1890. In late Victorian and Edwardian times, and up to the Second World War, great numbers of visitors came by train to Knaresborough, advertised in attractive posters. At Knaresborough station, the signal box is very unusual, in that it was built as an annex onto an existing row of terraced houses at No. 53 Kirkgate.

GAS LIGHTING
Soon after their formation in 1823, the Improvement Commissioners appointed the engineer John Malam to build the town's first gasworks on Waterside, near Low Bridge, at a cost of £6,000. The first gas lamps were lit on 13 September 1824, making Knaresborough one of the earliest towns to have good street lighting (Harrogate did not have gas lighting until 1845). To celebrate his achievement, Malam, at his own expense, replaced the eroded market cross with a gas lamp in 1824. By 1841, he had installed ninety-four public gas lamps and, by 1864, there were 129, with many homes gas-lit. In 1958, there were still 200 street gas lamps in Knaresborough. The town's last lamp-lighter, John Flynn of Halfpenny Lane, retired in 1975.

THE LITERARY AND SCIENTIFIC INSTITUTION
Founded in 1843, this was an early educational association, with around 120 members who met in the evenings to use a library of 1,500 books, hold discussions and hear lectures. In 1893, it held a Jubilee Celebration in the Oddfellows Hall, with a concert of songs and sketches.

RELIGION
The 1851 census reveals the religions of Knaresborough inhabitants as follows: Anglicans, 2047; Methodists, 843; Congregationalists, 227; Baptists, 105; Roman Catholics, 250.

FRIENDLY SOCIETIES
In addition to the Foresters and Oddfellows, Knaresborough, by the 1890s, had other mutual aid societies, including the Druids, who met at the Crown, and the Free Gift, who met at the Queen's Arms in Jockey Lane. From 1919, the Royal Antediluvian Order of Buffaloes began meeting in the Wellington, then the Hart's Horn, and finally, the Crown.

THE ROXY CINEMA
In the early 1930s, this was opened in the Oddfellows Hall by Robert Taylorson, who had come to Knaresborough from County Durham. He installed the latest sound projectors and welcomed his patrons, standing at the door in evening dress and white tie. Affectionately nicknamed 't' bug-'utch' and 't' laff an' scrat', the Roxy became a popular Knaresborough amenity, known for its Saturday matinees and double seats at the back. Later taken over by Star Cinemas, it was replaced by a bingo hall in 1962.

THE ZOO
In 1965, Knaresborough Zoo was established in the grounds of Conyngham Hall under Nick Nyoka, who made expeditions to the world's jungles to bring back exotic animals. These included Simba, at the time the biggest lion in captivity. The zoo became a popular

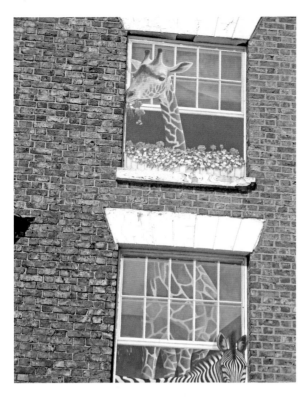

Zoo by Julie Cope.

tourist attraction, especially when Nyoka demonstrated snake handling. (*Nyoka* is Swahili for snake.) Irma the elephant was something of a filmstar, and shared her home with breeding bears, lions, tigers, llamas, wallabies, penguins and monkeys. In its heyday, the zoo attracted 150,000 visitors each year, 10,000 of these in school parties. However, by 1985, conditions were considered unsatisfactory by Harrogate Borough Council, who refused to renew the licence. A campaign to close the zoo was supported by a visit from Virginia McKenna; others pleaded for its retention, but there was no financial backing and, after an unsuccessful appeal, it closed in November 1986. Nick Nyoka died in 1995. Much of the zoo's land was used for the building of Henshaw's Art and Craft Centre in 1999.

GHOSTS
As with many old towns, Knaresborough has its share of apparitions and hauntings. One of the most persistent is the 'White Lady', said to be frequently seen in the castle area, is also associated with ghostly sightings of monks and soldiers. Other places claiming to be haunted include the Free Dispensary, the former Tudor Café (No. 12 Marketplace), parts of Silver Street, Manor Cottage, the Old Manor House, the icehouse of the Dower House, the old chapel (High Street), and various pubs, notably the Old Royal Oak in the marketplace.

HOSPITALS
The earliest known were the leper hospitals, set up by the friars of Knaresborough priory. The first Knaresborough Hospital was an adaptation of the 1858 workhouse in

Stockwell Road. It was used as a military hospital for convalescent servicemen during the First World War, when Lady Evelyn Collins was matron and Dr I. D. Mackay, and Dr W. J. Forbes were the medical officers. In 1925, the Princess Royal opened a new wing. There were separate nurses' quarters, with a maternity ward and a children's nursery. In the 1930s, the master and matron were the Alexanders, whose son Terrence became well known through the *Bergerac* TV series. Knaresborough Hospital developed as a modern geriatric unit, but in 1996 it was closed, and its attractive mock Tudor building demolished. Conyngham Hall had been used as a military hospital during the Second World War. In 1937, a sanatorium was built at Scotton Banks. When the need for the treatment of tuberculosis declined, this was adapted for use as a general hospital. In 1990, it was demolished and replaced by housing.

INNS

Knaresborough was renowned for its number of inns – seventy-four have been recorded during the eighteenth and nineteenth centuries. They all did good trade on market day,

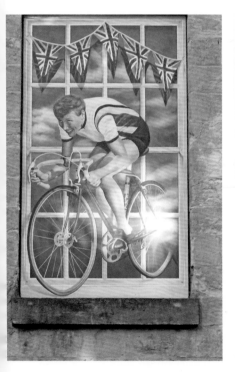 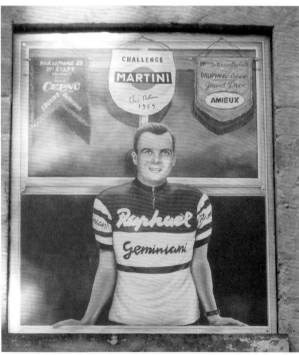

The 2014 Le Grand Départ Tour de France joins the Renaissance windows. Julie Cope is the artist. These two show two of Yorkshire's greatest cyclists: Brian Robinson who became the first Briton to complete the Tour de France (1955) and the first to win a stage (1958). Beryl Burton was the doyenne of women's cycling in the 1960s. She won the women's world road race championship in 1960 and 1967 and was runner-up in 1961. On the track, she specialised in the individual pursuit, winning the world championship five times – 1959, 1960, 1962, 1963 and 1966.

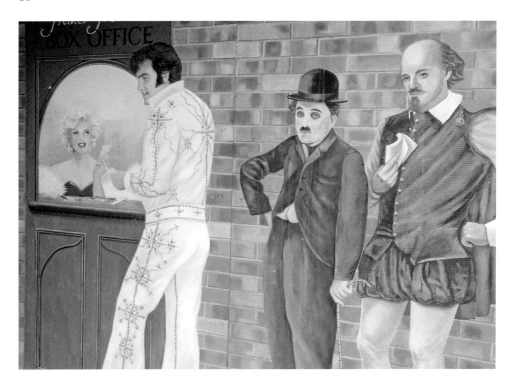

One of the superb wall paintings set up to mark the *feva* festival; this one paves the way to the Frazer Theatre.

and provided accommodation for spa visitors and travellers, as well as social centres for residents, with some offering cock-fighting. Many inns which no longer survive include the Barrel, the Elephant & Castle, the Star Inn, two called the White Horse and the Shoulder of Mutton. Others have been rebuilt, such as the World's End (1898), or replaced by a modern building on the same site, such as the Ivy Cottage. Some, however, have remained almost unchanged over the centuries, in particular the Old Royal Oak, the Mother Shipton (once called the Dropping Well), the Half Moon, the Crown, the Hart's Horn, the Marquis of Granby, the Borough Bailiff (once called the Commercial), the George & Dragon, and the Yorkshire Lass (formerly the George Hotel and the Murray Arms).

OLD ENGLISH LAVENDER WATER

This was originally made to a secret recipe by the Lawrence family, who sold it for many years in their Oldest Chemist's Shop. It was one of the most popular Knaresborough souvenirs, with the old-style bottle of lavender water, 'mellowed by age and of rare and subtle fragrance', encased in wicker, bearing a red seal stamped with the date of the shop's origin – 1720.

KNARESBOROUGH BOUQUET

Advertisements from the 1890s inform us that this is 'Without exception the Sweetest

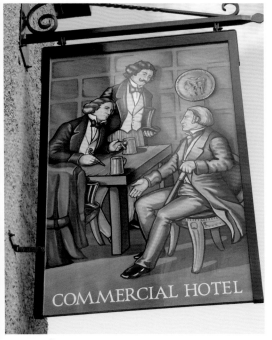

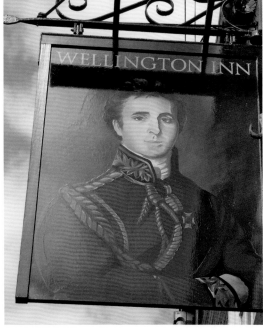

Four of the many inns of Knaresborough.

most refreshing and lasting Perfume. Its delicacy of odour surpasses many of the most expensive Perfumes.' Lily Langtry thought it 'Fragrant and delicate', while to Ellen Terry it was 'delicious'.

SANITATION

For much of its history, Knaresborough, though picturesque, was, like most towns and cities, plagued by offensive smells and insanitary practices. Even in 1764, when an Act of Parliament authorised a water supply pumped up from the Nidd, it had to threaten to punish those who put 'any filth, rubbish, cats, carcasses or carrion' into the river, conduits, reservoirs or cisterns'. A tainted water supply, dirty streets, uncovered ditches and dunghills, and single privies shared by many families, were a persistent health threat until the Improvement Commissioners started to tackle the problem. In 1850, the first effective sewage pipe was laid underneath High Street, but it was not until the early 1900s that there was a proper sewage system, with the luxury of the first water closets. The stinking content of earth privies was removed after dark by the 'night soil men' who, as recently as 1902, removed a total of 1,760 tonnes of night soil from the outdoor toilets of Knaresborough.

SHOEMAKING

The trade and craft of cordwaining, the making of boots and shoes was, for centuries, an important feature of Knaresborough's economy. There were sufficient cordwainers in the town to celebrate their patron saint, every St Crispin's Day (25 October), and the 1831 *Directory* listed no fewer than sixteen boot and shoemakers in Knaresborough.

RUGS

Rug making was another Knaresborough industry represented in the mid-nineteenth century by J. Clapham at Low Bridge, and by William Hartley in the marketplace. Clapham specialised in sheepskins.

BOATBUILDING

A modest amount of boatbuilding was carried out by Sturdy's. In the mid-nineteenth century, Sturdy had 140 boats compared to Charles Blenkhorn's ninety. Richard Sturdy (1837–1913) bought the business from William Bluett. Sturdy's was bought by Bill Henry, and then sold on to Harrogate Council in 1965.

THE 'KNARESBOROUGH AREA HOARD'

Not to be confused with the Roman era hoard. It was deposited *c.* 1135, and consisted of 178 silver coins, all Henry I BMC, type XV. The hoard was discovered by a group of metal detectorists between 2008 and 2009. The hoard was studied by the British Museum, before being returned to the landowner and finders in May 2011. All the coins are of good silver, uncleaned, with a mixture of bright silver and toned surfaces, some still having light traces of dirt on the surface.

RENAISSANCE KNARESBOROUGH

The organisation set up here, in 2004, to identify, develop and deliver projects to

improve the town. Recent work has included: Knaresborough riverside improvements; Horseshoe Field Bridge restoration; improvements at Bebra Gardens and Frazer Theatre improvements. Perhaps the most striking and attractive venture has been the *Trompe L'Oeil*, the town windows, a project with paintings by local artists to depict various aspects of the town's history. It began with the idea of extending the *Trompe l'Oeil* paintings that appear in Knaresborough town centre, as part of *feva,* to combine the *Trompe l'Oeil* style of visual trickery with the blind windows that appear on the upper floors of some of the town's Georgian buildings.

BLUE PLAQUES

At the time of writing, Knaresborough Civic Society had placed seventeen plaques to mark buildings of significant historical interest around the town. They are listed as follows: The Dower House, Bond End – built by Sir Thomas Slingsby, of Scriven Hall, in the fifteenth century for the Dowager. Sir Henry Slingsby has the rare distinction of being the last person to have his head stuck on Micklegate Bar in York, for being a dedicated but doomed,Royalist during the English Civil War.

John Metcalf, alias Blind Jack. Jack of all trades extraordinaire: road builder, army musician, guide, horse-trader etc. He died in 1810, and is buried in Spofforth graveyard.

The Mitre – Originally the Wheatsheaf, which changed its name to the Mitre in 1923. Bishop William Stubbs (1825–1901) was born here. He rose to become a distinguished theologian, an important church historian and the Bishop of Oxford. The Wheatsheaf was

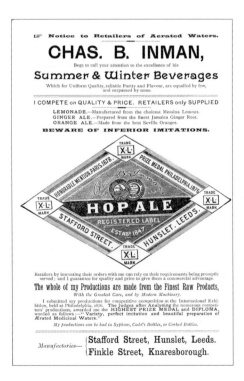

An 1890 advertisement for Knaresborough's Hop Ale, as brewed in Finkle Street.

the birthplace of George A. Moore CBE, KStJ, industrialist and businessman, who supported the town through many local causes.

The Old Manor House, Waterside – built in 1208, it was reputedly constructed around a still extant oak tree as a hunting lodge for King John. A mulberry bush, planted 400 years ago by James I, still flowers in the garden. Articles relating to the surrender of the Royalists were allegedly signed here, in the presence of Oliver Cromwell, at the end of the Civil War. From the seventeenth century, it was the home of the Roundell family for 400 years.

The Indigo Mill, Waterside – Indigo dye was made here from local woad, from the old dye house at the foot of Gallon Steps. The mill features in a Turner painting from 1797.

The Old Dye House, Gallon Steps – Built in 1610 by John Warner, it later became a boat store for Sturdy's, while, in the 1890s, it housed a small children's zoo. Warner, and his son Simon, a fervent Royalist during the Civil War, dyed locally produced textiles here until 1840.

Castle Mills, Waterside – A cotton mill built on the site of a paper mill; later it was a flax-spinning and weaving mill from 1770 until 1972. John Walton, the mill owner, received a royal warrant in 1834 from Queen Victoria, for services to the manufacture of linen, as 'suppliers to all the royal palaces'. Twenty-one converted dwellings now occupy the site.

The House in the Rock or Fort Montague, Abbey Road – The home of the eccentric Thomas Hill and his descendents. Fort Montague derives from Hill's benefactor, the Duchess of Buccleugh. Among other things, Hill flew the English flag, produced and used his own banknotes, and fired a canon.

The Chapel of Our Lady of the Crag, Abbey Road – This diminutive 12 x 8 foot Catholic chapel was hewn out of the rock, in 1408, by John the Mason, in thanks for the miraculous escape his son had from a tumbling rock. A Knight Templar guards the doorway.

St Robert's Cave, Abbey Road – Robert Fleure, a hermit who was born in York, lived here for thirty years in the thirteenth century – a popular destination for pilgrims for many centuries. His brother a Mayor of York, built the chapel. King John visited as a pilgrim in 1216, and awarded Robert 40 acres from which to feed the poor and destitute. St Robert died in 1218, and is buried in the chapel.

The Old Flax Mill, Green Dragon Yard, Castlegate – A former flax mill originating in the early nineteenth century, where raw flax, or linen, was combed in preparation for spinning and weaving in other mills. The building now is home to the wonderful Art in the Mill gallery.

Knaresborough Almshouse, Kirkgate – An imposing 600-year-old building, which served also as a hospital; a survey of 1611 described it as a hospital for six poor folk.

The Old Town Hall – top of Kirkgate – Built on the site of the old tollbooth, it was rebuilt in 1768 when it became the Sessions House hearing, infringements of the law, and boasted two prison cells underneath. It underwent further rebuilding in 1862. Election candidates delivered their speeches from the balcony between 1553 and 1867, in the days when Knaresborough returned two MPs.

Knaresborough Synagogue, the marketplace – The site where the thirteenth-century Jewish community worshipped. The community was probably dissolved in 1275, just before all Jews were expelled from the country by Edward I in 1290.

The Oldest Chemist's Shop, the marketplace – The last apothecaries were W. P. Lawrence MPS, PhD and his son, Edmund, who were in charge from 1884 to 1965.

Eugene Aram, White Horse Yard – Aram, facing trial for the murder of Daniel Clarke, wrote a suicide note describing himself as a victim of the legal system. He was, nevertheless, convicted on flimsy evidence and executed at York in August 1759, and his body draped on the gibbet in Knaresborough near Low Bridge.

Knaresborough House – built in 1768, under architect John Carr for the Revd Thomas Collins, vicar of Knaresborough from 1735–88. After 1951, it was in the hands of Knaresborough Urban District Council, and then Knaresborough Town Council.

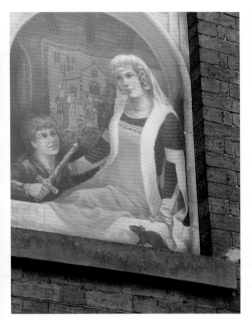

Above left: A beautiful example of one of the Renaissance windows, showing Queen Philippa and the future Black Prince. The rat signifies the Black death, which first cast its shadow on Knaresborough in 1349. The artist is Ray Mutimer.

Above right: Nine more windows, from top left to right: *Siege of Knaresborough Castle* by Shirley Vine at No. 53 Kirkgate; *Play Us a tune* (Blind Jack), by Peter Kearney in the marketplace; *Second Chances* (Guy Fawkes) by Julie Cope at Nos 5–7 Briggate depicting a detail; Julie Cope's self-portrait (detail from *Artist in Residence*) working on the window at No. 4 Castlegate; *Local Hero* (James 'Ginger' Lacey, World War Two fighter ace at No. 5 Gracious Street; *Alms for the Poor* (King John) by Peter Kearney at No. 1 Castlegate; detail from Julie Cope's *Zoo* at Nos 16–18 High Street; Julie Vine's *I Can See the World's End From Here* (Mother Shipton), from the Market Tavern, Castlegate; another detail Julie Cope's *Second Chances* (Guy Fawkes).

Further Reading

Anonymous, *A Week at Harrogate* (1913).

Anonymous, *Mother Shipton*.

Atkinson, W. A., *Knaresborough and Its Manor Houses* (1924).

Calvert, M., History of Knaresborough (1844).

Chrystal, P., *Knaresborough Through Time* (2010).

Chrystal, *Harrogate Through Time* (2011).

Chrystal, *A-Z of Knaresborough History* (2004, revised 2011).

Chrystal, *A Children's History of Harrogate & Knaresborough* (2011).

Cooke, D., *Yorkshire Sieges of the Civil War* (2011).

Deane, E., Spadacrene Anglica (1626).

French, J., *The Yorkshire Spaw* (1652).

Floyer, Sir J., *History of Cold Bathing* (1706).

Grainge, W., *Nidderdale* (1863).

Grainge, *Knaresborough* (1865).

Grainge, *Historical and Descriptive Account of Knaresborough* (1865).

Grainge, *The History of Harrogate and the Forest of Knaresborough* (1871).

Gent, T., *Life of St. Robert*.

Hargrove, E., *History of Knaresborough* (1775).

Hargrove, *Ancient Customs of the Forest of Knaresborough* (1808).

Hutton, W. H., *Life of Bishop Stubbs* (1906).

Inman, P., *No Going Back* (1932).

Jennings, B., (ed.) *A History of Harrogate and Knaresborough* (1970).

Kellett, A., *The Knaresborough Story* (1972, new edition 1990).

Kellett, *The Gracious Street Story* (1975).

Kellett, *The Queen's Church* (1978).

Kellett, *Knaresborough in Old Picture Postcards* (1984, new edition 1996).

Kellett, *Exploring Knaresborough* (1985).

Kellett, King John in Knaresborough: the first known Royal Maundy (*York Archaeological Journal*, 1990).

Kellett, *Companion to St John's* (1990).

Kellett, *Historic Knaresborough* (1991).

Kellett, *Knaresborough: Archive Photographs* (1995, new edition 2003).

Kellett, *Mother Shipton: Witch and Prophetess* (2002).

Kellett, *King James's School, Knaresborough: 1616–2003* (2003).

Kellett, *A-Z of Knaresborough History* (2004, revised 2011).

Kellett, *Blind Jack of Knaresborough* (2008).

Kershaw, M., *Knaresborough Castle* (1987).

Knaresborough Civic Society, *Knaresborough Conservation Area Buildings* (1973–1976).

Lewis, D., *Beauties of Harrogate and Knaresborough* (1798).

Metcalf, J., *Autobiography* (1795).

Slingsby, H., *Memoirs: Ed. Sir Walter Scott* (1806).

Speight, H., *Nidderdale* (1894).

Stubbs, B. P., *Genealogical History of his Family* (1915).

Stanhope, M., *Newes out of Yorkshire* (1626).

Cures without Care (1632).

Watson, E. R., *Eugene Aram* (1913).

Watts, RF, *King James's Grammar School* (1966).

Wheater, W., *Knaresburgh and its Rulers* (1907).

Knaresborough History Timeline

BC 10,000 Nidd Gorge formed, following the Ice Age.

BC 500 Ancient Britons (Brigantes) give a Celtic name to the River Nidd.

74 AD Romans finally defeat Brigantes, build Isurium Brigantum.

410 Angles build the fortified settlement of Knarresburg.

705 Synod of Nidd, recorded by St Bede.

867 First Vikings settle here following their capture of York.

1066 Norman settlement. Serlo de Burgh, first Lord of Knaresborough.

1070 Harrying of the North; brutal Norman suppression. Castle formed.

1086 Domesday Book 'Chenaresburgh' with villages, land for twenty-four ploughs.

1114 Knaresborough parish church granted by Henry I to Nostell priory.

1133 Eustace Fitz-John sends bread to starving monks building fountains.

1167 Forest of Knaresborough, established as a royal hunting-ground.

1170 Becket's four murderers, led by Hugh de Moreville, flee to castle.

1206 First visit by King John. First reference to Knaresborough Market.

1210 First known Royal Maundy, King John gives alms to thirteen paupers.

1216 King John visits St Robert in his riverside hermitage, grants him land.

1257 Priory of St Robert. Charter from John's son, Richard Plantagenet.

1300 Edward I, staying at castle, visits St Robert's tomb.

1310 Knaresborough granted its first known Charter by Edward II.

1312 Castle rebuilt for Piers Gaveston (twelve towers and a keep).

1314 Edward II orders Knaresborough men to march to Bannockburn.

1317 Castle taken by rebel knight John de Lilleburn.

1318 Castle recaptured. Scots raid town, burn church and 140 houses.

1328 Edward III and Queen Philippa, newly married in Knaresborough.

1331 Queen Philippa granted the Honour of Knaresborough by Edward III.

1343 Parish church restored and re-consecrated under Queen Philippa.

1349 The Black Death (bubonic plague) reaches Knaresborough.

1372 John of Gaunt, Duke of Lancaster, made Lord of Knaresborough.

1399 Richard II prisoner in Knaresborough Castle before murder at Pontefract.

1408 Chapel of Our Lady of the Crag excavated by John the Mason.

1488 Birth of Mother Shipton, according to legend.

1451 Sir William Plumpton secretly marries Joan Wintringham.

1461 Battle of Towton in War of the Roses. Many Knaresborough men killed.

1520 Miniature 'candle-snuffer' spire added to church.

1536 Pilgrimage of Grace. Protests against Henry VIII's reforms.

1540 Leland, Henry VIII's antiquary, praises castle, market, Dropping Well.

1553 Knaresborough returns its first two Members of Parliament.

1561 Parish Register started. Protestant service firmly established.

1588 Guy Fawkes moves to Scotton. Converted to Catholicism.

1600 Death of Francis Slingsby. Tomb in Slingsby chapel.

1605 Gunpowder Plot. Guy Fawkes fails to destroy King James.

1616 King James's Grammar School founded by Revd Dr Robert Chaloner.

1626 Dr Edmund Deane's Spadacrene Anglica promotes Knaresborough.

1638 Charity for giving bread to the poor – first of many.

1641 First account of Mother Shipton's prediction of Wolsey's downfall.

1642 Sir Henry Slingsby secures castle for Charles I.

1644 Battle of Marston Moor. Siege of Knaresborough Castle.

1648 Castle systematically demolished. Cromwell stays in Knaresborough.

1658 Sir Harry Slingsby beheaded on Tower Hill. Buried in parish church.

1660 Restoration of Charles II.

1666 George Fox visits Scotton and Knaresborough.

1688 Sir Henry Goodricke proclaims Prince of Orange as King William III.

1697 Independents' Barn chapel opens. Celia Fiennes in Knaresborough.

1717 Daniel Defoe stays in Knaresborough. Birth of Blind Jack.

1720 The Oldest Chemist's Shop in England opens in the marketplace.

1732 Blind Jack appointed fiddler for spa visitors at Harrogate inns.

1734 Eugene Aram starts school in White Horse Yard, High Street.

1735 Revd Thomas Collins, Vicar of Knaresborough (until 1788).

1737 Knaresborough's first workhouse built near parish church.

1739 Sir Henry Slingsby lays out the Long Walk to the Dropping Well.

1741 King James's Grammar School rebuilt on same site.

1742 First visits by John Wesley – Methodist meetings.

1744 Linen industry flourishing. Disappearance of Daniel Clark.

1745 Yorkshire Blues formed here, march to fight rebels in Scotland.

1759 Eugene Aram hanged in York for the murder of Daniel Clark.

1764 Act of Parliament authorises a water pump on the Nidd.

1765 Thomas Richardson's charity school opens. Blind Jack building roads.

1768 Knaresborough House, High Street, built for the Collins family.

1770 House in the Rock started by a poor linen weaver, Thomas Hill.

1774 First known fire engine. Peal of eight bells in parish church.

1785 Walton's linen manufacturers established. Sunday Schools start.

1795 First known public library in Knaresborough.

1791 Castle Mill built for cotton (later adapted for Walton's linen).

1796 Conyngham Hall built on site of Tudor Coghill House.

1803 Free Dispensary of Medicine started by Dr Peter Murray, Castle Inglis.

1810 Death of Blind Jack at Spofforth, where he is buried.

1814 Castle Boys' School opens as Church of England national school.

1815 Methodist chapel opens off Gracious Street. Cricket club founded.

1818 Death of Ely Hargrove, local historian, aged seventy-seven.

1822 Revival of Knaresborough Spa at Starbeck.

1823 Act of Parliament authorises Improvement Commissioners to run town.

1824 Gasworks constructed by John Malam. First street lamps.

1825 Birth of William Stubbs, later medieval historian, Bishop of Oxford.

1831 St Mary's Catholic church built at Bond End.

1837 Castle Girls' School opens, opposite Castle Boys' School.

1838 Queen Victoria appoints Walton's suppliers for all royal linen.

1843 Literary and Scientific Institution established.

1848 Collapse into Nidd of almost completed railway viaduct.

1849 Second outbreak of cholera – thirty-eight deaths. Dinsdale's grocers established.

1851 Viaduct rebuilt. Railway line to Starbeck opens.

1853 New free dispensary built in Castle Yard in memory of Revd A. Cheap.

1854 Opening of the Primitive Methodist chapel, off Briggate.

1856 Holy Trinity church completed, with 166-foot spire.

1857 First issue of *Knaresborough Household Almanack*.

1858 New workhouse, Stockwell Road, later Knaresborough Hospital.

1862 Town hall built on site of Borough courthouse.

1863 *Knaresborough Post* first published.

1865 Congregationalist chapel built, Windsor Lane. Castle Yard Riots.

1867 Reform Bill reduces Knaresborough's two MPs to one.

1868 New Wesleyan Methodist chapel, Gracious Street.

1869 Sir Charles Slingsby drowned in the Ure in a hunting accident.

1872 Restoration of parish church of St John's. Oddfellows Hall opened.

1876 Knaresborough Cemetery opened.

1885 Knaresborough loses right to elect an MP.

1887 Queen Victoria's Golden Jubilee. Knaresborough's 'Rejoicings'.

1895 Richardson's School amalgamates with King James's Grammar School.

1898 Kitching's timber merchants established in Knaresborough.

1900 Blenkhorn's New Century Dining Rooms, High Bridge.

1901 Grammar school moves to York Road, opened by Lord Harewood.

1903 Sellars leather factory burnt down. Chamber of Trade founded.

1904 Opening of Park Grove Methodist church.

1907 Cattle market at last moves from High Street.

1910 12 May, crowded marketplace to hear proclamation of George V.
1911 Population of Knaresborough still only 5,315 (Harrogate 33,703).
1913 Public electric lighting introduced.
1914 Outbreak of the First World War, hundreds of men volunteer.
1915 Council school moves from Gracious Street to Stockwell Road.
1916 Slingsby estate broken up and sold by public auction.
1918 End of war. Knaresborough has lost 156 men, killed in action.
1924 Sir Harold Mackintosh tenant of Conyngham Hall (until 1942).
1926 Public tennis courts opened in the castle grounds.
1929 Fysche Hall playing fields opened by Lady Evelyn Collins.
1931 Moat Gardens (later Bebra Gardens) opened near castle.
1942 Warship Week: Knaresborough greatest savings per head in country.
1945 End of the Second World War. Knaresborough has lost fifty-four killed.
1946 Conyngham Hall and grounds bought by Urban District Council.
1947 Philip Inman of Charing Cross Hospital, Lord Inman of Knaresborough.
1950 Water Carnival revived. Population of Knaresborough 8,590.
1953 Celebration of Coronation. New market cross dedicated.
1960 Friendship and leisure centre opened in the marketplace.
1962 Knaresborough Players founded, later move to Frazer Theatre.
1965 Knaresborough Zoo opens. (Closed in 1986).
1966 First Bed Race. 350th Anniversary of King James's Grammar School.
1968 First Boxing Day tug of war: Half Moon v. Mother Shipton's.
1969 Town twinning. Albert Holch chairman of council for sixth time.
1971 King James's School starts as eleven–eighteen Comprehensive on same site.
1972 Duchess of Kent officially opens King James's School Pageant.
1973 Churchyard of St John's cleared and landscaped.
1975 Methodist church rebuilt in Gracious Street.
1977 Courthouse Museum opened.
1983 First fun run held by King James's School.
1984 Collins Court opened by Lady Elizabeth Collins.
1985 First known Royal Maundy in Knaresborough established.
1986 Hewitson Court opened in memory of Cllr P. W. Hewitson.
1988 First Edwardian Christmas fair.
1990 Opening, after long campaign, of Knaresborough swimming pool.
1996 First Knaresborough festival of poetry, arts and music (later *feva*).
1999 Henshaw's Arts and Crafts Centre opens.
2000 New millennium opens – church bells, fireworks, Millennium Pageant.
2002 The marketplace reordered and partly pedestrianised.
2014 Le Grand Départ, Tour de France, passes through Knaresborough.

*This is a revised version of *A Knaresborough History at a Glance,* which first appeared in Arnold Kellett's *A to Z of Knaresborough History* (2004), and subsequently in the edition revised by Paul Chrystal in 2011.